DETROIT SLUGGERS

THE FIRST 75 YEARS

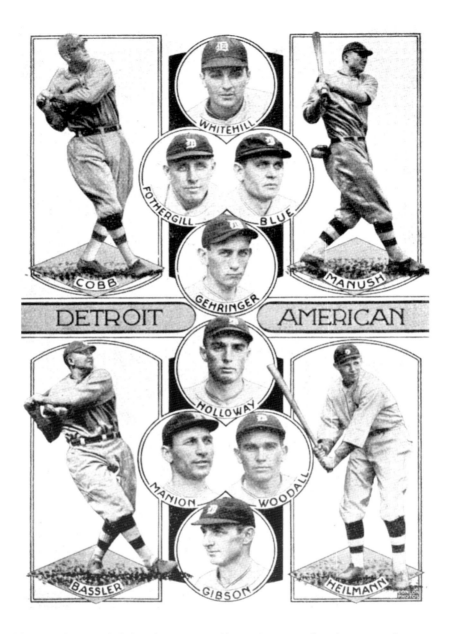

The *Spalding Guide* included this decorative collage of Detroit's best hitters in the 1927 issue.

On the front cover: Ty Cobb, with his famous bat, poses on deck in 1912. (Courtesy of Transcendental Graphics.)

On the back cover: Jack Burns, Goose Goslin, Billy Rogell, and manager Mickey Cochrane confer in the dugout in late 1936. (Courtesy of Transcendental Graphics.)

Cover background: Please see page 118. (Courtesy of Transcendental Graphics.)

DETROIT SLUGGERS

THE FIRST 75 YEARS

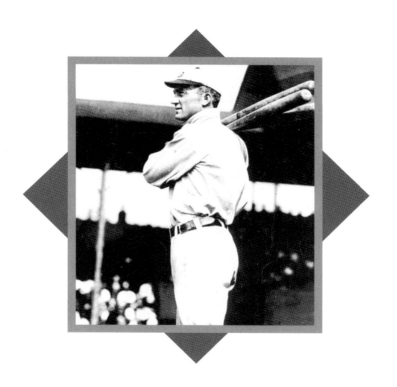

Mark Rucker

ARCADIA
PUBLISHING

Published by Arcadia Publishing
Charleston SC, Chicago IL, Portsmouth NH, San Francisco CA

Printed in the United States of America

Library of Congress Catalog Card Number: 2006923724

For all general information contact Arcadia Publishing at:
Telephone 843-853-2070
Fax 843-853-0044
E-mail sales@arcadiapublishing.com
For customer service and orders:
Toll-Free 1-888-313-2665

Visit us on the Internet at www.arcadiapublishing.com

CONTENTS

GEO. S. HARRIS & SONS. LITH. PHILA.

In the Victorian era, Detroit men smoked cigars and they liked their baseball. The promotional combination was a popular one, as seen with this handsome cigar box label from around 1880. Imitation dollar bills have been used as spoofs for advertising since the currency was invented. On the opposite of the top page, they use the portrait of Wolverine's manager William Henry Watkins on a trade flyer for a boot and shoe store.

Detroit in the

National League

We Tiger fans have been through a lot. We have seen some of the greatest players in the history of baseball playing in Detroit; we have seen great teams come and go; and, recently, we have seen the opening of a new stadium, to replace old Tiger Stadium, which was earlier known as Briggs. Way back in the 19th century, when Detroit was developing from a fur trading center into an industrial giant, the population grew to a level where a major-league ball team was feasible. And, in 1881, the Detroit Wolverines Base Ball Club was formed, shortly after the ferocious beasts had roamed the Upper Peninsula. Players were brought in from nearly every National League team, including Cincinnati, Cleveland, Chicago, Providence, Worcester, Troy, Boston, and Buffalo. Out of nowhere we had a respectable team!

By 1887, we would win the pennant and play the St. Louis Browns of the American Association for the championship of the world. Not only did we play them, but we whipped them good, 10 games to 5. But the happy hangover from wearing the crown did not last long, as we are a fickle group sometimes here in Detroit. With the team unable to keep up its quality play from the year earlier, we slipped in the standings, and slipped even more in attendance, to the point where the club pulled up stakes and left after the 1888 season. We could not believe it! Our great hitters—Dan Brouthers, Sam Thompson, Deacon White, and Fred Dunlap—all gone! We were sick, and remained bereft of good ball play for many years, hoping for professional baseball to come back to town. By 1894, Detroit became part of Ban Johnson's Western League, considered just below major-league level at the time. Johnson was to grow the league and transform the conglomerate into the new American League in 1901, which has been dubbed the "Junior Circuit" ever since.

Ned Hanlon
Career 1878–1893 Detroit 1881–1888

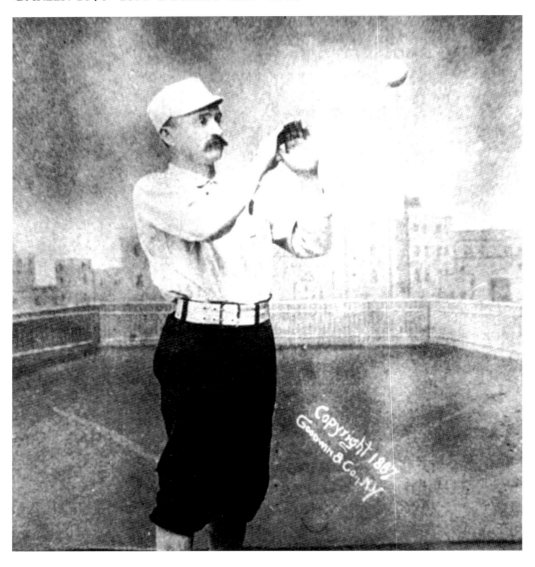

Wily Ned Hanlon played center field for the Wolverines from 1881 to 1888—every year we were in the National League. He was never hired for his bat, but for his unrivaled patrolling of the outfield. Nevertheless, Hanlon hit .302 in 1885 while garnering 128 hits; his lifetime slugging percentage was an acceptable .340. Once in a while, Hanlon would play second base or shortstop, but he was an outfielder for all but 20 games in his career. Known more as a manager than a player, Hanlon never led the team in Detroit. He first became a manager in Pittsburgh and later drove the famous Baltimore Orioles of the 1890s to consecutive championships in the National League. Hanlon's managerial expertise is

what put him recently into the Baseball Hall of Fame in Cooperstown. But it was his speed that we found most entertaining. The speedster covered our center field with grace and ease and burned up the base paths as well. As proof, just check his record for legging out triples. He hit eight triples three times, and 10 triples once, doubling up his lifetime home run totals. Hanlon had 79 triples over his 13-year career, as compared to only 30 homers in all those years.

George Wood
Career 1880–1892 Detroit 1881–1885

George "Dandy" Wood, born in Boston in 1858, was another of our outfielders in the 1880s. Once in a while he would pitch or play the infield, but 95 percent of his total innings was in the garden. And when he got hot, we loved to watch him run out triples, recorded by scorekeepers at a 132 lifetime total. He hit 19 triples for the Wolves in 1885, the same year when his slugging average went to .428, with only 19 strikeouts the entire year.

Charlie Bennett was a household name in Detroit. He was our backstop for our entire National League run. He was our backbone, and our leader, our man in the middle, who ran the team as much as the manager did. Later he was the sad victim of a railroad accident where he lost his legs. He and a teammate were a bit late for the team train, which they chased down the platform as it was leaving the station. Bennett slipped, fell under the train, and ended his baseball career. He remained a ballpark favorite, and he became a civic leader. We named the ballpark after him, he was so popular.

Joe Quest
Career 1878–1886 Detroit 1883, 1885

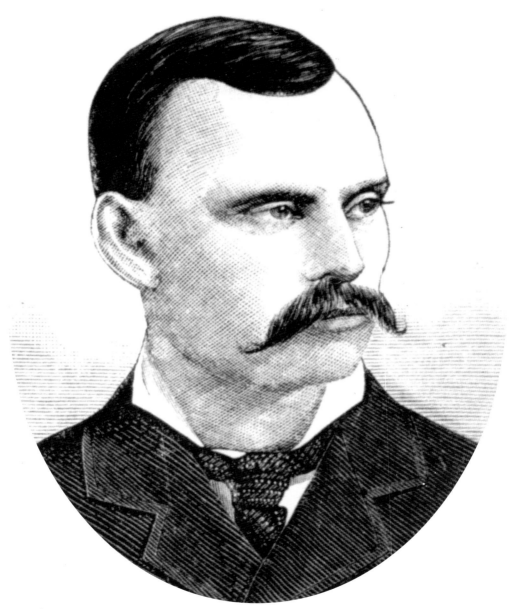

Pennsylvania native Joe Quest stopped by Detroit in 1883 just long enough to demonstrate the proper way to play second base and swing the bat; then by August he was on his way to the Browns of St. Louis. But in 1885, he was back, playing a whole season.

Alonzo Knight, dapperly dressed above, was with Detroit's National League team when we entered the league in 1881. He covered all three outfield positions for us, working in the infield only occasionally. He left Detroit after 1882 to play in his hometown of Philadelphia.

FRED DUNLAP
CAREER 1880–1891 DETROIT 1886–1887

"Sure Shot" Fred Dunlap was a hitting and fielding star for two championship clubs, one in St. Louis and one in Detroit. In the pennant-winning year of 1887, in 65 games Dunlap scored 60 runs and drove in 45. To help even more, he blasted five triples and stole 15 bases. But after the long season of 1887 was over and the flag flew over the ballpark in Detroit, Dunlap moved on to Pittsburgh to play for the Pirates.

Utility expert Sy Sutcliffe could catch or play any position in the infield or in the outfield. He played but one year in Detroit, where he hit .257 in 49 games. He never knew where he would be playing. During that one season, he caught 14 games, played shortstop in 24 games, first base for five games, second base for two games, and outfield for four games.

Dan Brouthers
Career 1879–1904 Detroit 1886–1888

Copyright 1887
Goodwin & Co.

Big Dan Brouthers was our favorite giant. He stood six feet two inches in a time when men were short. He used every bit of his strength to pound the baseball for 19 years in the major leagues. His .343 lifetime batting average is ninth best of all time, leaving records and memories in his wake, like the time we saw him go six-for-six in 1886, as he clubbed three home runs that day. We had him for three fantastic seasons, and right in the middle was our World Championship. In 1886, he led the league with 40 doubles and a .581 slugging percentage. Then in 1887, as we stormed past the competition, he again topped the league with 36 doubles, while his 153 runs beat all others. He again led the league in runs in 1888, the team's last season in Detroit. Brouthers was one of baseball's biggest stars, and, like today, he followed the money and fame to Boston to play with the powerhouse Beaneaters, where he won a batting title in 1889. Brouthers finished his career with a staggering .519 slugging percentage, plus he hit 106 home runs in an era when round trippers were very scarce. His 11 in 1887 was best in the National League. To the left is a photograph of Brouthers from the 1887 series of Old Judge cabinet photographs. Above is a shot of Dan when he played in Buffalo.

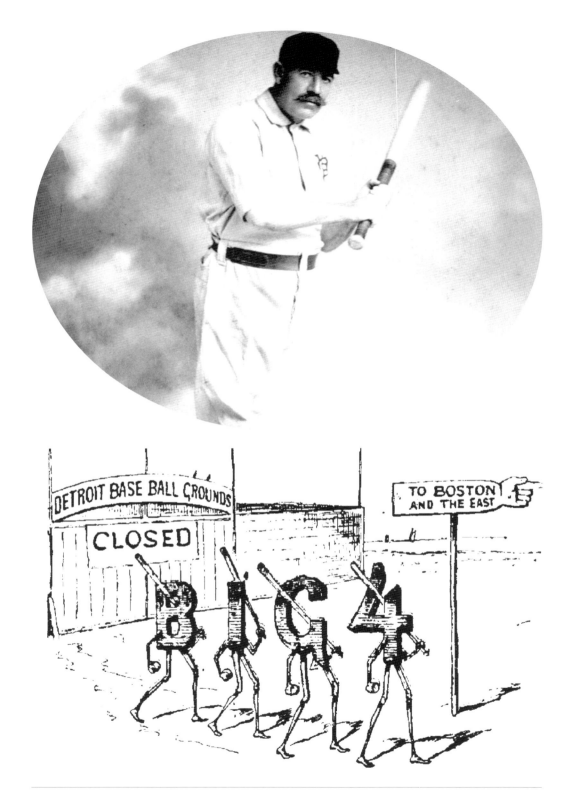

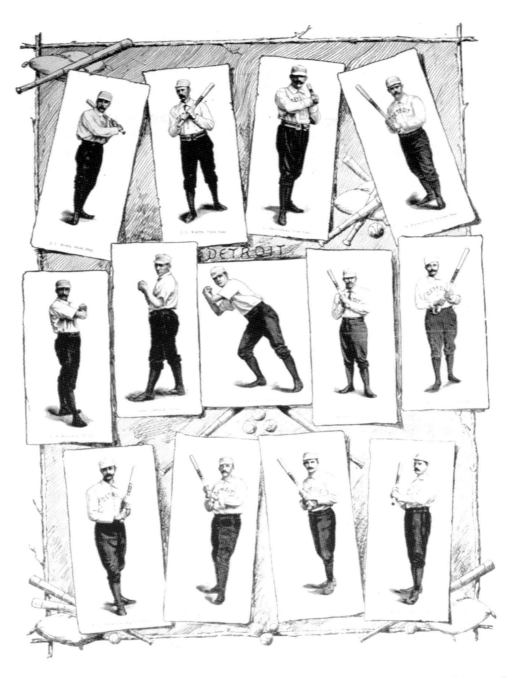

Dan Brouthers, opposite page top, was one of the big four sluggers for the Wolverines, as the cartoon opposite page bottom illustrates. Above, this 1887 *Illustrated News* woodcut depicts Brouthers and his three compatriots. Brouthers is in the top row, second from right; Deacon White is top row, second from left; Jack Rowe is in the top row, far left; and Sam Thompson is bottom row, far left.

DETROIT SLUGGERS

Jimmy Manning (left) and Sam Thompson share the page above. Manning got to play in Detroit at the best possible time. His 1885 to 1887 stay in our town coincided with celebrations and success. He was a utility fielder, sometimes filling in for teammate Thompson, who roamed right field for the Wolverines. Thompson became a Hall of Famer from his hitting prowess and consistency. In 1887, the Wolverine Base Ball Club was a hitting machine.

DETROIT IN THE NATIONAL LEAGUE

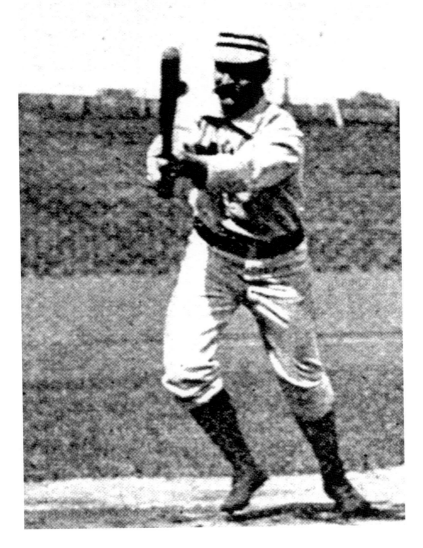

With men always on base, it is no wonder that Thompson was able to knock in 166 runs to lead the team, and the league, as he also did with his .372 batting average and his .571 slugging percentage. He played the outfield for every game of the 1887 season, as he racked up 23 triples that year, too. Above is a rare action shot of Thompson taking a cut at a pre-game pitch. Action photography from this era is almost unknown, but we can thank a Philadelphia photographer for this one.

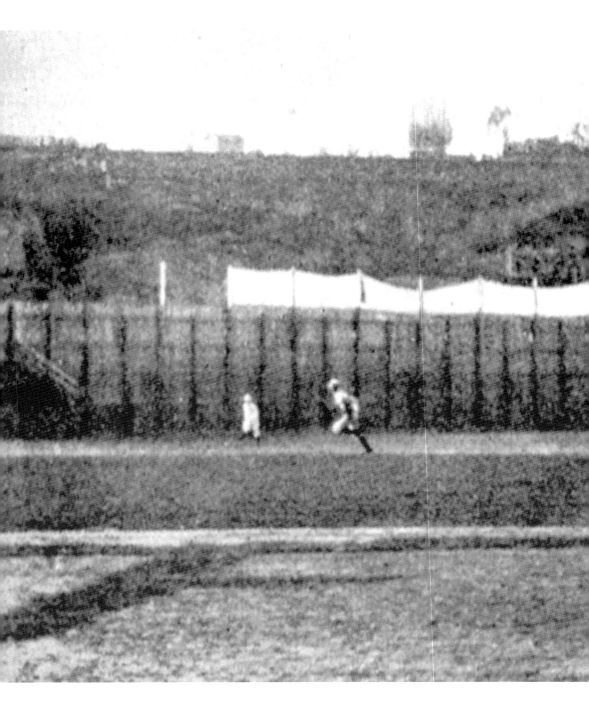

Wow! We could not believe this photograph. It shows Sam Thompson rounding first base, urged on by his coach, as an unidentified teammate is heading for third. The action took place in New York's Polo Grounds, with famous Coogan's Bluff in the background. Thompson was playing for Philadelphia in the National League at that time, but the picture illustrates game action like

DETROIT IN THE NATIONAL LEAGUE

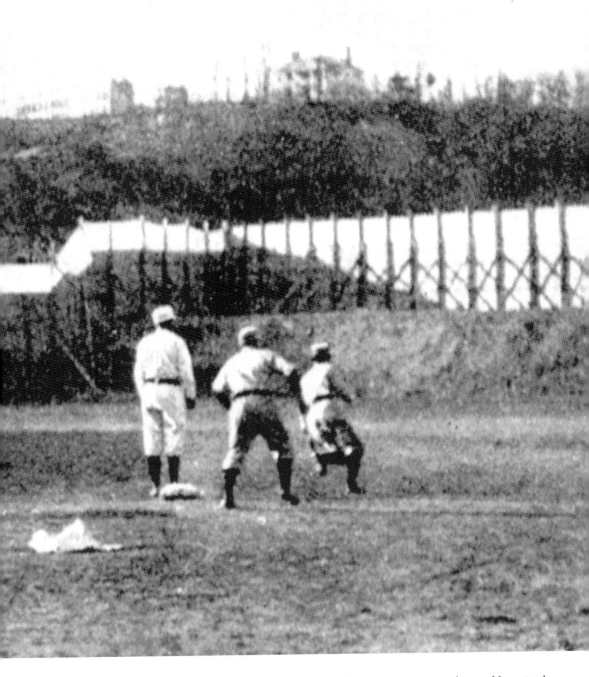

few others. Thompson played for the Phillies for the rest of his 15-year career, almost. He retired from the diamond in Philly in 1898, but he made an misadvised comeback attempt with Detroit in 1906. The comeback lasted 8 games.

CHARLIE GANZEL
CAREER 1884–1897 DETROIT 1887–1888

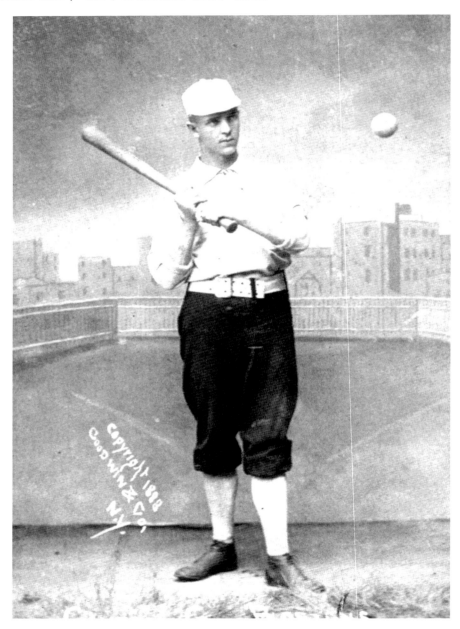

Charlie Ganzel appears in a Detroit uniform in the 1888 photograph above. Our colors were blue and white, and Ganzel wore them mostly behind the plate, substituting for Charlie Bennett when he needed a rest. He was a solid major-leaguer, good hitter, and was relied upon by pitching staffs for his abilities as a backstop.

THE WESTERN LEAGUE
AND THE
AMERICAN LEAGUE

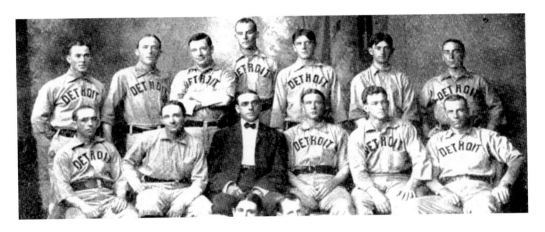

The 1901 reincarnation of major-league baseball in Detroit, as pictured above, ended a long hiatus and also marked an end to the league our team had played in since 1894. After the 1900 season, persistent Ban Johnson finally convinced National League owners that the quality of play in his Western League was worthy of major-league status. So as the Western League became the American, the Tigers were born as a major-league franchise. Our patience had been rewarded, Detroit was a big-time town again, and we were about to see some of the best baseball ever played.

We got off to a shaky start in 1901, with the team composed of lesser-known Midwestern players. We finished third that first year, and followed that with seventh and fifth place finishes. But the worst was in 1904, when we finished seventh again, losing 90 games for managers Ed Barrow, and then Bobby Lowe. In 1905 and 1906, we did little better, but hired Hughie Jennings over the winter to manage the club the following year.

In 1907, Ty Cobb arrived in the Motor City and transformed the team into a winner. An unexcelled clutch hitter, winning batting titles in 12 different seasons starting as a rookie, Cobb would terrify pitchers and infielders alike with his maniacal base running. Harry Heilmann hit over .400 in 1923, a feat which Cobb accomplished twice. About a decade after Cobb had left, Hank Greenberg entered major-league baseball through the portals of Briggs Stadium, and proceeded to crush the ball throughout his entire career in Detroit.

BARRET, Fielder, Detroit

Billy Lush, above left, spent one of his seven major-league seasons in Detroit. He was fleet of foot and covered the outfield well for the Tigers, plus his .274 batting average in 1903 was his best ever. But management thought they could do better and sent Lush on to Cleveland at the end of the season. Jimmy Barrett, above right, was our star center fielder for five full summers in Detroit. He had a powerful arm and led all outfielders in the American League in assists three different times. A speedy and talented fielder, Barrett also had a keen batting eye, as illustrated by his league-leading records in bases on balls in 1903 and 1904. The stocky left-hander batted over .300 twice for the Tigers, .303 in 1902 and .315 in 1903, when he also whacked 10 triples and scored 95 runs. Barrett moved on in 1906 to play with Cincinnati and then the Boston Red Sox, where he finished his big-league career with a .291 lifetime batting average. William J. Gleason, opposite page left, was known to all in baseball as "Kid," dating back to his arrival in Philadelphia in 1888. Kid Gleason pitched and played the infield for 22 years in both the American

WILLIAM J. GLEASON

DOC CASEY

and National Leagues. He came to Detroit before their first National League season, and he played a sharp second base for us for until 1902. Gleason was a major baseball talent, a four-tool player who could do everything but hit with power. He scored 82 runs in 1901 in 135 games, then played only 118 in 1902 when his run total dropped to 42. Gleason is most famous for being the unaware manager of the World Series–throwing Chicago White Sox in 1919. Next to Gleason above is Doc Casey, our third baseman for 1901 and 1902. A solid right-handed hitter, his 102 runs scored in 1901 was the best on the team, while reaching the top 10 in the American League. Casey batted .283 and .273 in his two years in Detroit. Casey was a pitcher in the minor leagues, successful despite his small frame. His work in the New England League was the inspiration for Hall of Famer Nap Lajoie to give professional ball a try. Casey was a dentist, thus his nickname "Doc;" we could visit him any day in the drugstore he ran in the city after retirement, which he kept open until his death in 1936.

Ducky Holmes
Career 1895–1905 Detroit 1901–1902

Perhaps nicknamed Ducky because he was not, problem-child Jim Holmes could not keep his mouth shut. Holmes insulted citizens, umpires, and teammates alike, which probably led to his playing for four teams in two years.

While in Detroit in 1901, Holmes hit .294 and knocked in 62 runs, with a slugging average of .406. Holmes ended his 10-year career with the 1905 White Sox.

Lew Drill had a great name for a hitter, but he was in the majors only four years, catching in two of them for the Tigers. Drill also played for the Washington Senators and on each team would bat each season in the .250 to .260 range, which was fine for a backstop. He retired from the game at 28, after completing the 1905 campaign in Detroit. He finished his career with 292 major-league games under his belt.

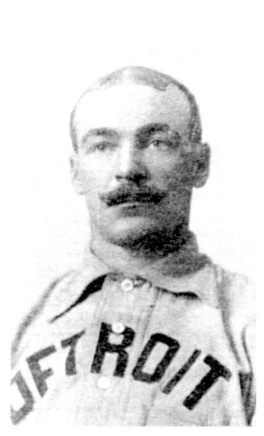

The portraits of Deacon McGuire (left) and Lew "Sport" McAllister are echoed in the 1903 Tigers team collage on the opposite page. Within McGuire's astounding 26-year major-league career, he played in Detroit four different times, the shortest stay being a three-game stopover in 1888, and the longest being two full seasons from 1902 to 1903. The hard-bitten catcher played in 1,781 games, 1,611 of them behind the plate. He accumulated 1,749 total hits, and most of us can still remember the 1,749th. He played in one game that season of 1912, and he looked like a middle-aged man, indeed, he was 49 years old at the time. He came in after the starting catcher was injured, strode to the plate twice, and singled and scored a run. It was the last we would see of the Deacon. Sport McAllister, above right, was a jack-of-all-trades journeyman when he got to Detroit in 1901, where he played every position but pitcher in the next three seasons. In 1901, he hit .301 in 90 games for our Cats, as he drove in 57 runners. In 1903, he closed out his final year with a .260 batting average, 31 runs scored, and 69 hits in 78 games played.

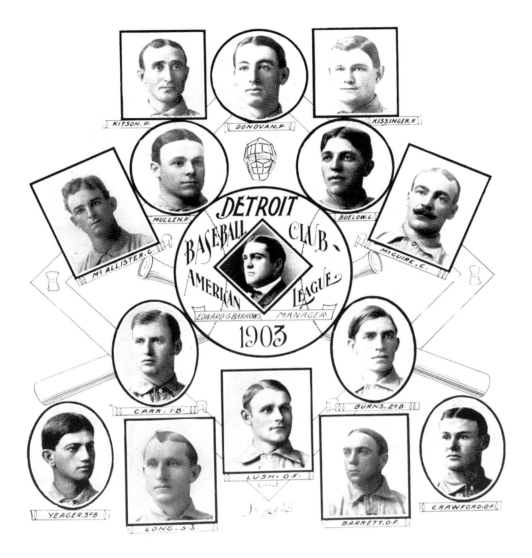

KITSON. P. DONOVAN. P. KISSINGER. P.

MULLEN. P. BUELOW. C.

McALLISTER. C. McGUIRE. C.

DETROIT
BASEBALL CLUB.
AMERICAN LEAGUE
EDWARD G. BARROWS, MANAGER.
1903

CARR. 1.B. BURNS. 2°B.

YEAGER. 3°B. LUSH. O.F. CRAWFORD. O.F.

LONG. S.S. BARRETT. O.F.

For three or four years in the mid-1900s, the *Sporting Life* baseball newspaper would issue sets of team prints, with collages like the one above. This 1903 version placed manager Ed Barrow at the center; "Wahoo" Sam Crawford at the lower right; Deacon McGuire in the second row from the top, far right; and Sport McAllister, in the second row from the top, far left. This club was sometimes fun to watch, especially when they could display their speed on the base paths. But their 65-71 record attests to a lack of success, which in this case was a combination of too much age and too little talent. Herman Long had been a fabulous shortstop for 12 summers in Boston, but he was 37 when he got to town in the middle of the 1903 season, after which he played only one more game, with the Phillies, before he retired. Charlie Carr, second row from bottom on the left, was our first baseman for the entire 1903 campaign, when he collected 154 hits, and most of the 1904 season, when he slumped most of the year.

Kid Elberfeld (above left) and Bill Coughlin, who arrived in Detroit in July 1904, were pictured on baseball cards issued by a candy company, which are in scarce supply today. Elberfeld was known as the Tabasco Kid, for it was his inflammable personality that made him so fun to watch. Playing shortstop for us for four seasons, he loved to taunt opponents to try to spike him when sliding into second base. And then he would pour hard liquor over his own wounds as treatment. He was out of the hard-nosed deadball mold, where baseball was a contact sport and everybody liked it that way, including the fans. Elberfeld was also a speedster, stealing over 200 bases in his career. In addition, he hit over .300 in two of his three years here, while in 1903, his on-base percentage was .412. Bill Coughlin became our mainstay at third base, and although always a team leader, was not made captain until 1906. He helped guide us to pennants in 1907 and 1908, both with his skillful play at third and savvy advice in competition. He was a solid .250 hitter who could hit with some power and scored a lot of runs.

It was Wahoo, Nebraska, Sam Crawford's hometown, that gave him his nickname, not any behavioral quirks. After four seasons in Cincinnati around the beginning of the 20th century, the Reds foolishly let him go. Crawford loved it in Detroit to the point where he spent the rest of his career in our city. He was a .300 hitter from his first season, recording .300 seasons eight different times with the Tigers.

Six-foot-one-inch-tall Sam Crawford had a long reach with a bat. He hit the ball all over the yard, our favorites being the huge number of triples he compiled over the months and years. No other play is more exciting than a triple, unless you count inside-the-park home runs. Crawford hit 309 three baggers in all, leading the American League in 1902, 1903, 1910, and 1913 through 1915 and topping all players for all time. The year 1914 saw Crawford whack 26 triples, helping

him to drive in a league-best 104 runs. He did it again in 1905, increasing the RBI number to 112. Crawford was also an aggressive base runner, who was usually successful in double steals. In 1908, his seven home runs led the league, making him the only player in the history of the game to lead both leagues in homers. He was particularly good in combination with Ty Cobb, who would show up in 1907 and change things forever.

BOSS SCHMIDT
CAREER 1906–1911 ALL IN DETROIT

Charles "Boss" Schmidt was a pugilist before becoming a ballplayer, even taking on heavyweight champion John L. Sullivan once in an exhibition bout. He was pugnacious on the field as well, beating up Ty Cobb a number of times when disagreements heated up. His leadership qualities helped carry us through for three straight pennants starting in 1907. Oddly, he is the only player ever to make the last out in consecutive World Series.

Hughie Jennings played only sporadically during his managerial years in Detroit. His best years as a player were behind him, but he brought great times to Detroit, as his Tigers won three straight flags under his guidance. He was famous for his dance of excitement in the third base coaching box, and he never failed to perform for a photographer. He would rib and challenge opponents and give umpires the business at every opportunity, while encouraging his Tigers to play smart and play hard. Hughie stayed on as skipper throughout the 1920 season.

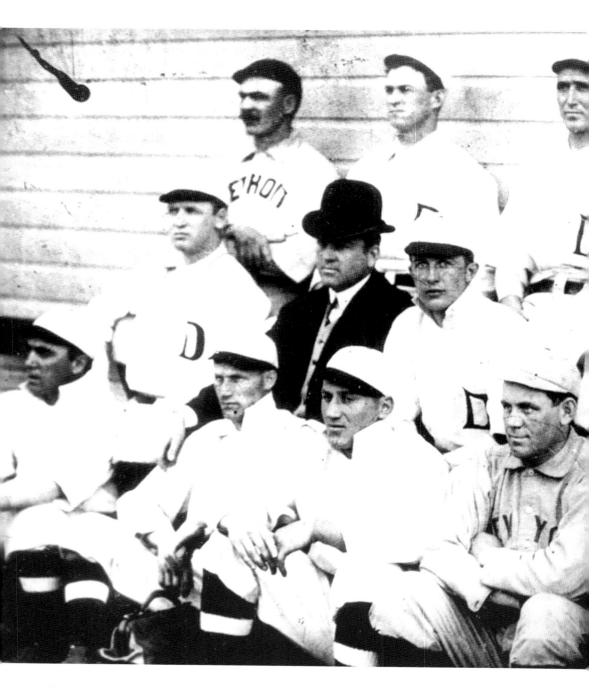

The 1904 Tigers posed for this shot early in their season. This photograph was taken at spring training, as attested to by the appearance of Monte Beville (front row, fourth from left), who still wears his New York Highlanders uniform from the year before. Ed Barrow, the manager who would last until mid-season, wears the derby. The club finished in seventh place that year, winning 62 and losing 90. The team batting average was worse than all others in the American

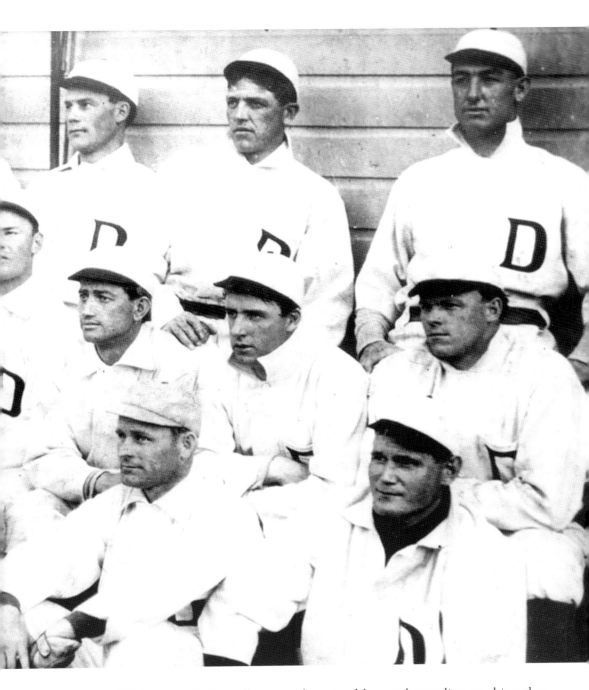

League except Washington. In fact, all our numbers stood low on league lists, as this rather lackluster club played out the season, and we fans waited for something to cheer about. It would not take long, but we did not know that. For us, it was another year of floundering, marked by a few winning streaks. But we were basically dominated by the competition, and we wondered what could possibly pull us out of these doldrums.

Matty McIntyre
Career 1901–1912 Detroit 1904–1910

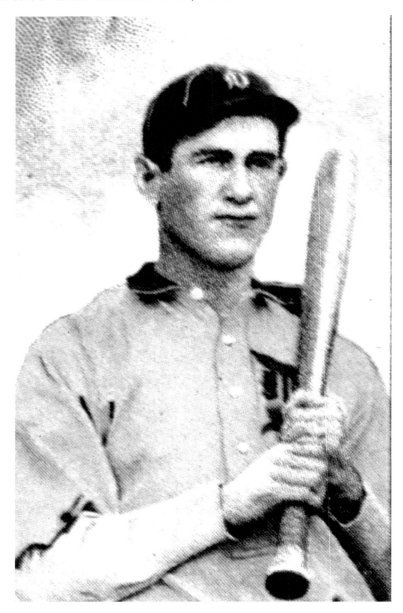

Matty McIntyre was the forgotten third of our early-20th-century outfield, covering left field while Cobb roamed center, and Crawford right. McIntyre was quick and skillful and fun to watch. He hit more than 10 triples three times and twice scored more than 100 runs in a season, leading the American League with 105 in 1908. He played 1,025 games in Detroit, but almost no one noticed.

"Tioga" George Burns played his first four seasons in Detroit. He showed early talent with his bat, hitting .297 as a rookie in 137 games, all at first base. He played as a regular but was shipped to the Athletics, where he remained for two and a half years. But it was in Cleveland, in 1926, that Burns had his career year, winning the Most Valuable Player award in the American League, tying Sam Rice for the league lead in hits (216), leading the league in doubles (64!), while his 114 RBIs were second only to Babe Ruth.

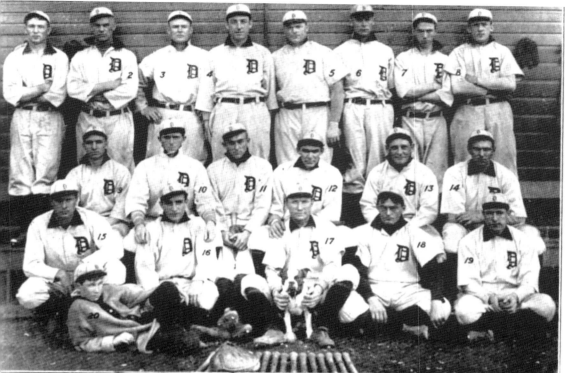

Eubanks	2 Rossman	3 Crawford	4 Donovan	5 Mullin	6 Willits	7 Payne	8 Killian
	9 D. Jones	10 Downs	11 Cobb	12 Coughlin	13 Schaefer	14 E. Jones	
	15 Seiver	16 Archer	17 Jennings	18 Schmidt	19 O'Leary	20 O'Brien, Mascot	

TIGERS—1907

The 1907 team shot of the Tigers above was reproduced on posters, trade cards, postcards, sheet music, plates, cups, calendars, paperweights, bedspreads, lantern slides, pennants, buttons, and stickpins, as well as our World Series program. This juggernaut of a team, led by the ferocious Ty Cobb, rookie winner of the batting title, won 92 games for manager Hugh Jennings. Jennings sits in the front row, center, holding the team mascot, a bulldog of some kind. Cobb is in the middle row, third from left, with Bill Coughlin to his left and Germany Schaefer next to him. Sam Crawford stands in the back row, third from left, while Boss Schmidt front row, second from right, is to the right of Charlie O'Leary, one of our shortstops. A quick look at the accomplishments of this club is eye-opening.

We led the league in hits with 1,383, in runs scored with 694, a team batting average of .266, on-base percentage of .313, and a slugging average of .335. Our pitching staff was good, led by Wild Bill Donovan, back row, fourth from left, and Ed Killian, back row, far right, but we all thought it was our hitters that got us through. The 75 triples that Cobb and Crawford and a few others hit did not hurt our cause, either. Winning the pennant was sweet, but the season came down to the wire. We finished a scant game and a half ahead of the Philadelphia Athletics, who had a great team that year. Connie Mack and crew pushed us all year long, but our bats were better than theirs, and we won out in the end.

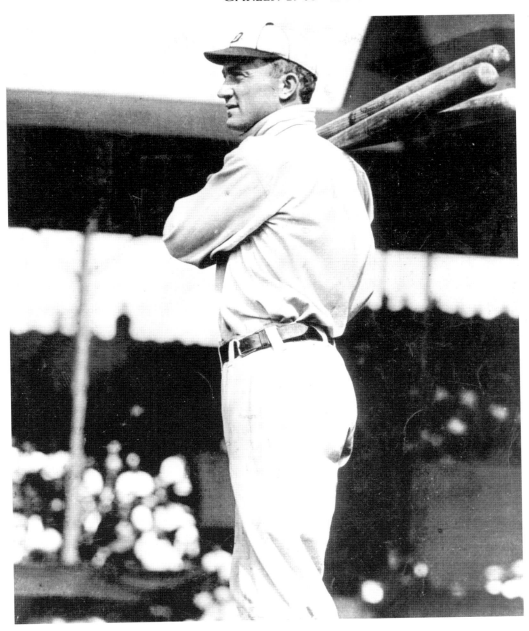

Many books have been written about Ty Cobb, his records, and his personal problems. We really did not care about any of that in Detroit, as long as Cobb maintained his intensity, which he always did. Cobb was the kind of player you would always want on your team but never want to live next door.

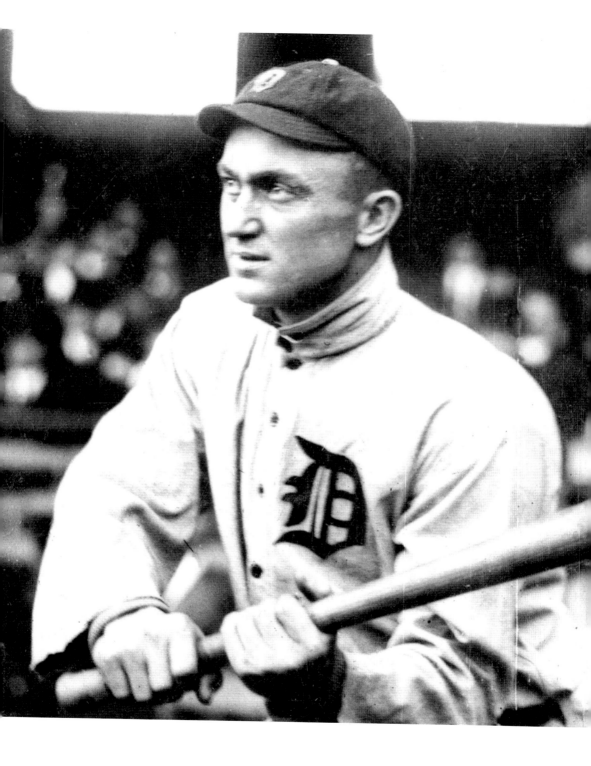

THE WESTERN LEAGUE AND THE AMERICAN LEAGUE

Cobb did not get along well with his manager, he did not get on with his teammates, and, in fact, he did not get on with himself. Even from the stands you could see Cobb was a driven, tortured individual, who drove himself harder than anyone else could. He actually did sit on the dugout steps sharpening his spikes, and he used them to hurt the opposition both on the scoreboard and on the legs. He knew no other way to play, and the aggressiveness was contagious. From the moment he arrived at spring training in 1907, everyone involved with the team knew something had changed. Increasing our number of wins from 71 to 92 in one season was unbelievable, and it had to be Cobb who was the catalyst. Suddenly Crawford's slugging feats meant more, as run production went higher and higher with Cobb's hit totals and stolen bases. The photograph at left illustrates the intensity in the Hall of Famer's eyes as a pitch approached the plate.

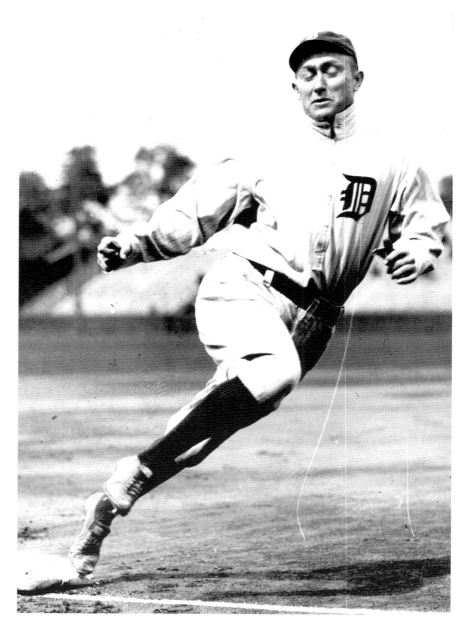

Photographer Charles Conlan was always glad he snapped the photograph above. He caught Cobb rounding third in a pre-game session, and he found takers for his photograph wherever it was offered. Conlan's most famous shot of the "Georgia Peach" shows him sliding into third baseman Jimmy Austin in a cloud of dust.

Cobb was no doubt photogenic. But all his records, all his hits, all his stolen bases, all his batting titles, and all the accolades he received could not make him happy. That was the hardest thing for us in Detroit to understand when Cobb was on the field.

TIGER CHAMPIONS
1909

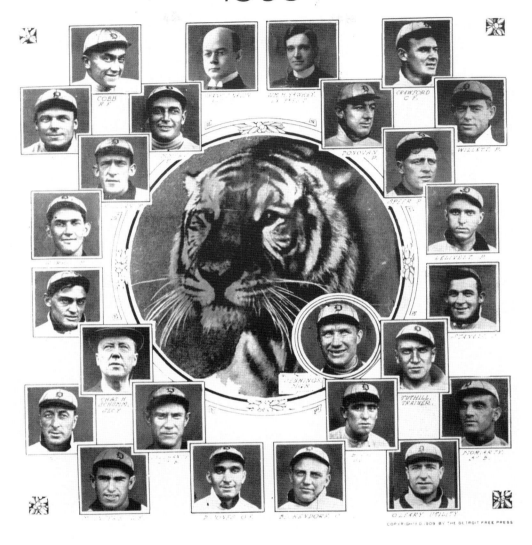

This 1909 Tiger club was the last of the three-year wonders to win an American League pennant. The 98 games we won that year was the team's best, ahead of the Athletics again, this time by three-and-a-half games. Without Cobb and Crawford, top row, far left and far right, respectively, the team could never have taken the league. The one-two punch they provided will never be seen again in Detroit; it was a once-in-a-lifetime experience for the city. Between them in 1909, they made 401 base hits, hit 68 doubles, scored 199 runs, while driving in 204. Our only frustration in those pennant-winning years is that we never took the World Series.

DETROIT SLUGGERS

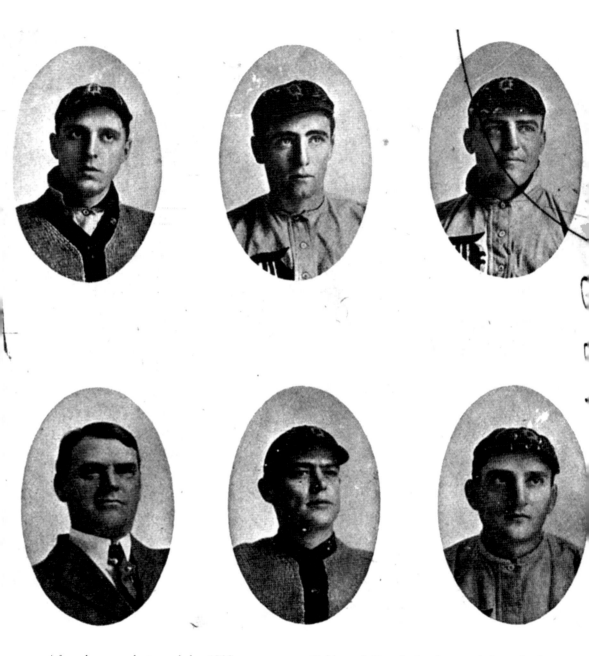

After the completion of the 1909 season, sans Cobb and Crawford, who needed no further work or income, the Tigers took a tour to the sunny, warm baseball-mad island of Cuba. As a special memento for fans there, a local entrepreneur at the Cabañas cigarette company arranged to produce insert cards of the players making the trip. Of course, the Cubans wanted to see Detroit's best, but were still thrilled to get a major-league team into town once more. The above proof sheet from the printer who made the cards contains all the portraits of the team. Silk O'Laughlin the umpire (bottom row, far left) came along as an arbiter for the series of games

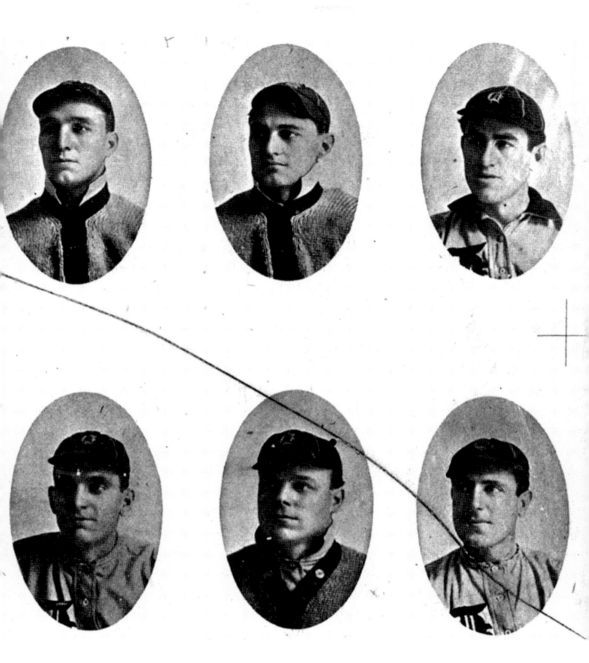

against the Habana and Almendares teams. Pitcher Ed Willetts is to the right of O'Laughlin, while George Moriarty, our third baseman, appears in the bottom row, third from right. The top row features, from left to right, Bill Lellivelt, who began his major-league career in 1909; Donie Bush, our shortstop; Heinie Beckendorf; center fielder Davey Jones; catcher Boss Schmidt; and left fielder Matty McIntyre. Charlie O'Leary, second base, appears in the bottom row, far right. The tour was a complete success, and the players loved the Caribbean, as opposed to Michigan, in winter.

Del Gainor
Career 1909–1922 Detroit 1909–1914

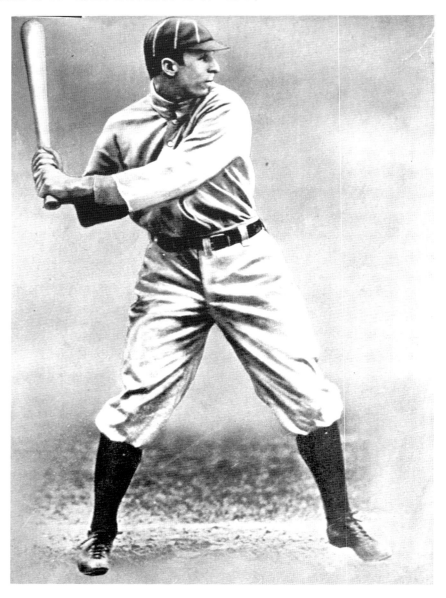

"Sheriff" Del Gainor spent his first five seasons in the bigs in a Detroit uniform. By 1913, he was our regular first baseman, a season where he picked up almost 100 hits and scored 47 runs. He did not make it to the majors in time to play with the Tigers in any of our consecutive World Series appearances, but it was a later series in which he became famous. In game two of the 1916 World Series, the Boston Red Sox and Brooklyn Dodgers were tied at one after 13 innings when Gainor stroked a single to win the game for Beantown.

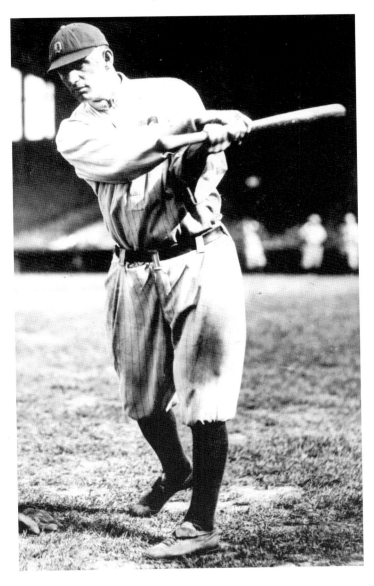

George Moriarty, one of our Cuban travelers, enjoyed a 13-year stay in the majors, playing mostly third base. He was always a solid hitter. He stayed with the Tigers longer than with any other club, which, outside of five games with the Cubs in his rookie year, was all in the American League. He arrived in Detroit to bolster the 1908 pennant winners, adding 43 runs scored and 39 runs batted in to our hitting attack. Plus, we really loved his glove. After leaving baseball as a player, he became an American League umpire for 22 years and returned to Detroit one final time as a Tiger scout in the 1940s.

Bobby Veach
Career 1912–1925 Detroit 1912–1923

For 11 summers, we watched Bobby Veach patrol left field and bash the ball all over the park. He twice led the American League in doubles and more impressively led the league in RBIs three different times. In those 11 seasons, he batted over .300 eight times, his best being .355 in 1919. His talents were seldom noticed because of other Tiger stars, like Sam Crawford, Ty Cobb, and the soon-to-arrive Harry Heilmann, but he was a key cog in our machine in the teens.

In Oscar Stanage's first two seasons in Detroit, he split time at catcher with veteran Boss Schmidt, but by 1911, he was our starter, receiving for 141 games. He was never counted on as a hitter, but was too important to the pitching staff to let him go. He had a lifetime .234 batting average and had only eight home runs in his career, but his expertise behind the plate was undeniable.

Donie Bush
Career 1908–1923 Detroit 1908–1921

Donie Bush was a better ballplayer than he was a manager, so it was lucky for us he only *played* in Detroit. He was a leadoff hitter and great with the on-base percentage, as he led the American League in walks five times, and he could steal bases, to boot. He could never top Ty Cobb on the base paths, but they formed a spectacular one-two punch for us all decade.

In every single all-time offensive category for the Tigers, you will see Harry Heilmann's name. All but his last two campaigns were in Detroit, and all the records he accumulated could not all be described here. Harry was also an iron man. From 1916 to 1929, Heilmann was always in the lineup, except for a stint in the Navy in World War I in 1918, and in 1922 with a broken collarbone.

Ossie Vitt
Career 1912–1921 Detroit 1912–1918

By 1915, Oscar Joseph Vitt was Detroit's regular third baseman, but it was his glove more than his bat that kept him in the lineup. Hitting .250 or more was considered a good season for the San Francisco native, who soaked up baseball knowledge during his playing days and became an outstanding major-league manager.

George Harper played until he was 44, then looked back on a fine career. He began in the big leagues as a Tiger, playing more games in the outfield each year, until he left after the 1918 season. His finest moment came years later when he hit three home runs in one game for the Cardinals in 1928.

It's Ty Cobb again, still hitting the ball hard as we approached 1920. There were only two years when the Tigers wore the uniform Ty Cobb is sporting above. That was in 1918 and 1919, when Cobb was still winning batting titles and piling up base hits. The photograph above shows Cobb taking some pre-game batting practice in the Polo Grounds, when the Yankees played there. Cobb was famous for his batting technique in which he separated his hands on the bat for greater control. But, as we can see in this picture, he could finish his swing with hands together when he wanted to hit with power.

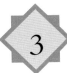

THE 1920s

TIGERS IN THE TANK

We galumphed into the 1920s having not seen an American League winner since 1909. In the winter between 1920 and 1921, Ty Cobb took over as manager from Hughie Jennings, and the Tigers entered a new dark age. The best we could muster was a second-place finish in 1923, but it was never close, with the Tigers finishing 16 games in back of the Yankees. Otherwise we would end up somewhere from fourth to sixth in the league of eight. But don't get me wrong, we still loved our baseball, we still loved the team, and there was always something going on worthy of our attention. But Cobb was such a troublesome character that despite the entertaining headlines his actions might produce, he was decidedly wrong for the team, absolutely wrong as a manager. He lasted for six years, based mainly on that second-place finish in 1923, but George Moriarty, who took over in 1927, was no better and lasted but two seasons, having produced a fourth-place record in 1927, and sixth place in 1928. Bucky Harris took over in 1929 and stayed into the 1930s, laying the groundwork for winning teams in the mid-1930s.

Win or lose, the games were great, and we loved watching our parade of hitters, who must have been inspired, if not intimidated, by the famous Cobb. He had set the standard in Detroit, and along with slugging Harry Heilmann, our Cats of the early 1920s proffered a potent one-two punch. Bobby Veach was in left field, next to Cobb and Heilmann, combining for the most fearsome outfield threesome in baseball. Charlie Gehringer, our outstanding longtime second baseman showed up first in 1923, then for a short time again in 1924, and became the starter for the season of 1925. Gehringer was one of three future Hall of Famers, joining Cobb and Heilmann in Cooperstown. Just these three outstanding batsmen were worth the price of admission. The number of Hall of Famers grew to four when Heinie Manush rose from the minors into the Tiger fold, but we did not hang on to him despite the fast start of his career. He won a batting title in his fourth year, but after slumping in 1927, the brass gave up on him and sent him to the St. Louis Browns. By 1927, Ty Cobb was gone, both as a player and a manager, and by 1930, Heilmann was gone, establishing a whole new look to the ball club.

Bucky Harris arrived as manager to accompany this changing of the guard. Harris had his own ideas, and he wanted to mold the ball club into something new, as the old stars were leaving. Harris was waving goodbye to an era when the team's hitting prowess alone would bring victories, while Cobb and Heilmann were leaving behind their prime years in the game and a boatload of memories that they shared with Detroit's loyal fans.

IRA FLAGSTEAD
CAREER 1917–1930 DETROIT 1917–1922

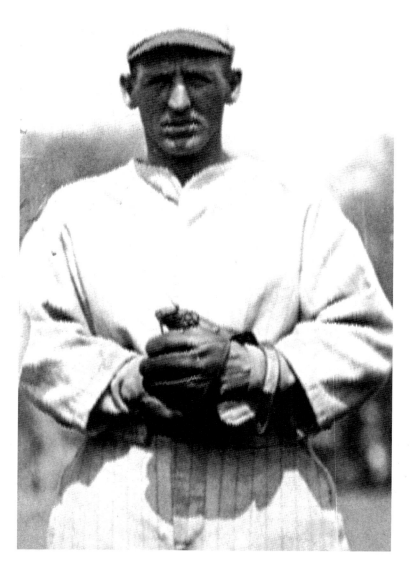

Center-fielder Ira Flagstead hit .300 in five different seasons, twice for our Tigers. Not a power hitter, Flagstead always did his part with a bat, playing for Boston, Washington, and Pittsburgh after leaving the Motor City. In 1926, while playing for the Red Sox, Flagstead tied a major-league record by starting three double plays from the outfield in the same game. His .290 lifetime batting average attests to his skill at the plate.

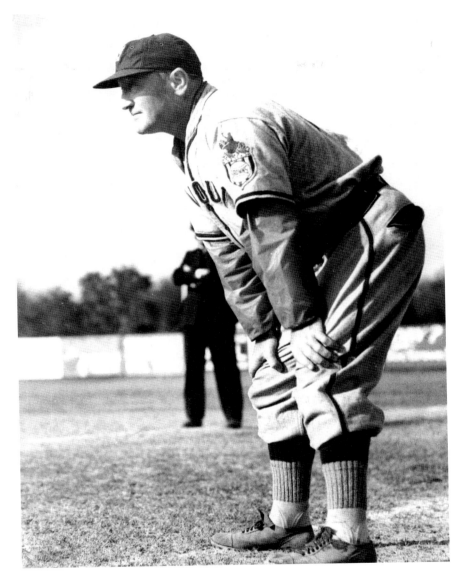

Playing mostly third and second base for the Tigers as his career began, Fred Haney did not know he would later become much more productive as a manager. He hit well in Detroit, but after a trade to the Red Sox, he started to slip, and by 1929, at only 31 years old, Haney was finished in the majors. He managed in both the minors and the majors, the pinnacle of his achievements was the winning of two consecutive National League pennants for the Milwaukee Braves in 1957 and 1958, and taking the World Series from the Yankees in 1957.

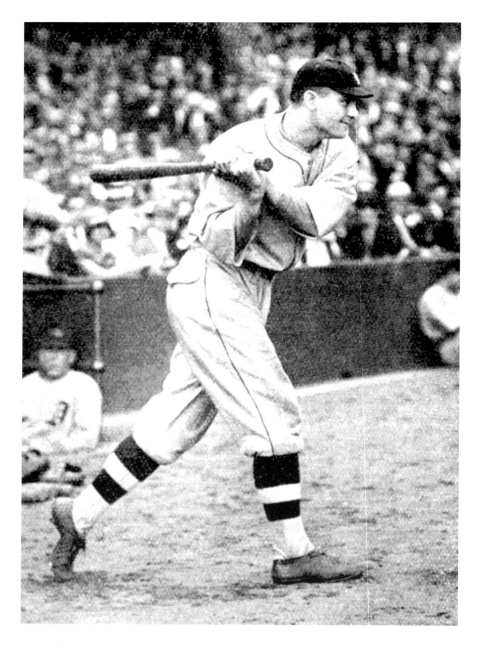

Henry Manush was nicknamed "Heinie," like so many other ballplayers of German extraction. If Manush's talents were not recognized or rewarded in Detroit, they certainly were later in his career when he moved to the St. Louis Browns and Washington Senators. But in truth, Manush played as well for us as he did anywhere else. Our other big guns grabbed headlines from Manush, who even won a batting title in 1926, beating out Babe Ruth and Heilmann, with a .378 average. That same year, he took over center field from Ty Cobb and was to play one more year with us, before his year-long slump caused him to be

shipped to the Browns. He was a power hitter, specializing in knocking doubles into the outfield gaps, and employed his speed to add up 160 three baggers in his career, 50 more than his home run total. Manush was finally recognized in the best possible way when elected to the Hall of Fame in 1964.

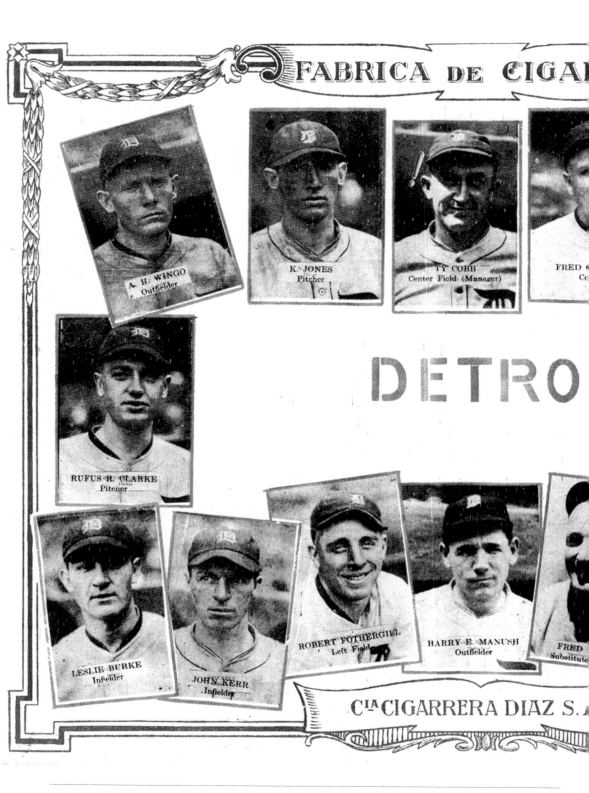

FABRICA DE CIGA[RROS]

A. H. WINGO
Outfielder

K. JONES
Pitcher

TY COBB
Center Field (Manager)

FRED [C.]
C[o]

DETRO[IT]

RUFUS R. CLARKE
Pitcher

LESLIE BURKE
Infielder

JOHN KERR
Infielder

ROBERT FOTHERGILL
Left Field

HARRY E. MANUSH
Outfielder

FRED
Substitute

CIA CIGARRERA DIAZ S. A.

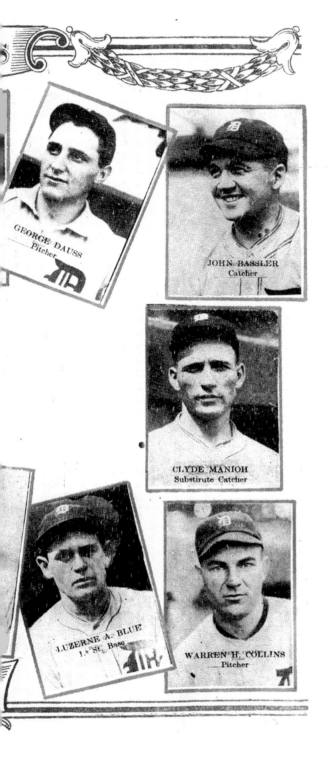

GEORGE DAUSS
Pitcher

JOHN BASSLER
Catcher

CLYDE MANIOH
Substitute Catcher

LUZERNE A. BLUE
1st St. Base

WARREN H. COLLINS
Pitcher

Cubans continued to follow American baseball, as they did back in 1909, as tobacco companies in Havana continued to use baseball to advertise their products. The team collage at left from 1924, issued by the Tomas Gutierrez Company, contains portraits of some players we could find nowhere else. From left to right, in the first row, we see Les Burke, John Kerr, Bob Fothergill, manager Fred Haney, Lu Blue, and pitcher Warren Collins. Les Burke played half the time at second base for us from 1924 to 1926. Johnny Kerr's first two years in the bigs were with the Tigers as a utility infielder. He played for eight total years, all in the American League. Bob Fothergill covered the outfield in Briggs Stadium for us for seven straight seasons in the 1920s. It was a good thing Fothergill could hit hard line drives, because his slowness on the base paths was legendary. Harry Heilmann's picture is mislabeled Harry Manush. And in the top row, far right, is a shot of our catcher Johnny Bassler, a hard hitter who was in the running for the American League's Most Valuable Player in 1922, 1923, and 1924. The year 1924 was his best year ever, hitting .346 in 124 games behind the plate.

Al Wingo
Career 1919–1928 Detroit 1924–1928

Al Wingo, whose brother Ivy was also a major-leaguer, played extremely well for us in six seasons and then was gone. One amazing set of circumstances we real Tiger fans will never forget occurred in 1925. Wingo, with his 163 hits in 130 games, hit an astonishing .370, but hardly anyone noticed. His fellow Tiger outfielders were better, with Cobb hitting .378, and Harry Heilmann leading the league with .393.

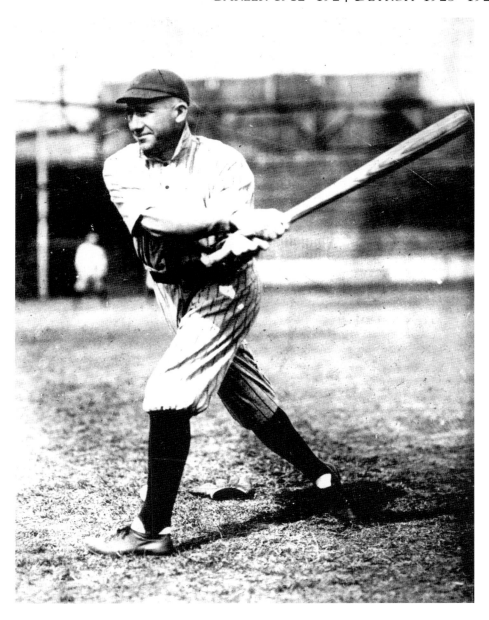

The years 1923 and 1924 were the last major-league seasons for Del Pratt, who was one of the American League's best second basemen for 13 years. He had starred for Miller Huggins's Yankees during the teens, playing about 150 games a summer with them. In his career, he ended four hits shy of 2,000, with an excellent batting average of .292.

Frank O'Rourke
Career 1912–1931 Detroit 1924–1926

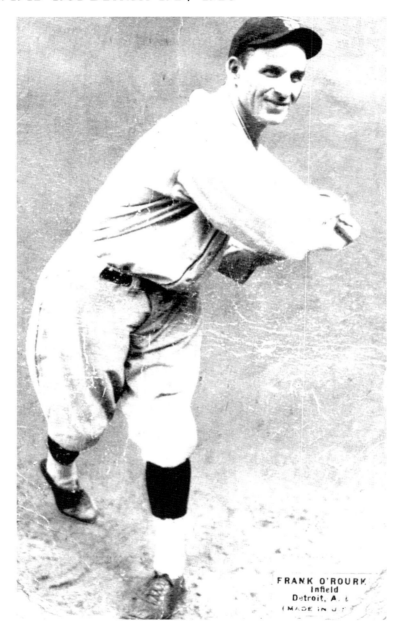

FRANK O'ROURK
Infield
Detroit, A. L
(MADE IN U...

Canadian native Frank "Blackie" O'Rourke worked hard after arriving in Detroit in 1924, and by the next season, he had locked up the Tigers's second base job. But fate is always working, and a bout of measles during the middle of 1926 gave O'Rourke's position to young Charlie Gehringer, who would hold down second until 1942, some 2,323 games later.

Clyde Manion's catchers mitt kept him in major-league work for 13 years, but not his bat. In the six seasons he played backup to Johnny Bassett, he never hit a home run, and if the stories are true, never hit one in batting practice, either. In fact, after 1,153 at bats, Manion could only manage three home runs. We always hoped for the best, but Clyde was not born to hit.

Bucky Harris
Career 1919–1931 Detroit 1929, 1931

After Bucky Harris was hired as the Tigers manager in 1929, he only had 11 more games at second base left in him. He had been a star at the keystone for 10 seasons in Washington, where he also managed the Senators to two World Series appearances. But at age 33, he was determined to bring the pennant to Detroit as soon as possible.

George "Clancy" Cutshaw was also a second baseman and was just about done with his baseball career when he arrived in Detroit in 1922. He was a tough man to strike out and often hit in the cleanup spot before 1922, but he earned his paycheck with his glove. He played one and half years in a Tiger uniform before he hung them up.

Charlie Gehringer
Career 1924–1942 all in Detroit

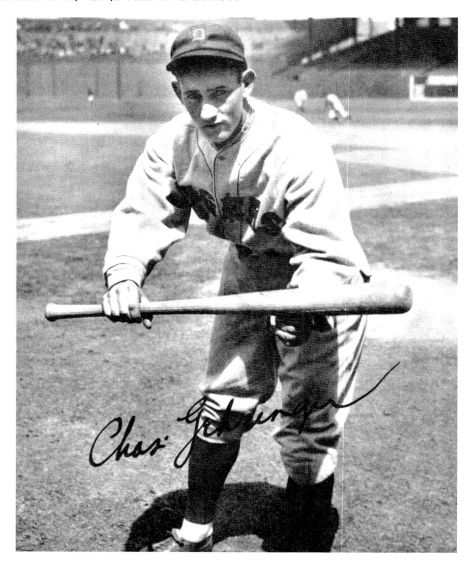

Charlie Gehringer was one of the top second basemen to ever play the game, and one of the quietest. Gehringer looks somewhat shy in the photographs we have of him, but whether it was shyness or a monk's need for silence that made him so taciturn, we never knew. He did not say. Doc Cramer said of teammate Charlie, "You wind him up opening day and forget him;" so not surprisingly he was nicknamed "The Mechanical Man." In reality, he was more business-like than robotic. His fundamentals in the field were so sound and his agility so swift that impossible-seeming plays became commonplace. His batting fundamentals were equally sound, as his .320 lifetime average attests. His records and achievements in the field

could fill many pages, but his batting records should not be forgotten. He led the American League in hitting with a .371 mark in 1937, the one year he won the American League MVP award. In seven different seasons, Gehringer had 200 hits or drove in more than 100 runs, and was voted to the All-Star team six times. While creating such a numerical commotion, Gehringer could go almost unnoticed on the field. While playing next to more flamboyant comrades like Lynwood "Schoolboy" Rowe or Hank Greenberg, Gehringer could easily hide from the reporters and cameramen, quietly honing his skills well out of the baseball spotlight. It was the old Tiger Bobby Veach who found Gehringer playing for the University of Michigan and got him to sign with our club. He was an early-ballot Hall of Famer, elected just seven years after retirement in 1949.

EARL WEBB
CAREER 1925–1933 DETROIT 1932–1933

Outfielder Earl Webb played in Detroit but two years, actually a part of two seasons. He hit both years in the high .200s, but he did not fit in with Detroit's plans and could not force his way into the everyday starting lineup with his bat. However, in the 88 games he played for the Tigers in 1932, he recorded 19 doubles, eight triples, and three home runs.

Gee was short for Gerald, but Gee was not short at all. Five-foot-11-inch, 188-pound Walker was a fan favorite in Detroit both for his fun-loving hijinks on the stadium sidelines and for his skill and intensity on the field. His initial six seasons were with the Tigers, and we enjoyed them all, watching Gee pound out 93 RBIs with only 12 home runs, and then a year later in 1937, producing 113 RBIs with 18 homers, and a batting average of a whopping .353.

PETE FOX
CAREER 1933–1945 DETROIT 1933–1940

Pete Fox roamed right field under the Briggs Stadium overhang for eight full seasons, beginning his rookie year. A strong batter in the minor leagues, Fox came to Detroit via the Texas League, where he led all hitters in 1932 with a .357 average. He helped build our pennant-winning outfield during those thrilling campaigns in the mid-1930s. Fox was also a good glove man, while he hit over .300 thrice for the Tigers, and built a reputation as a doubles hitter. In different years in Detroit, he knocked 31, 38, 39, and 35 two baggers, driving in critical runs all the while.

Joyner White came from Red Oak, Georgia, but did not mind playing ball in the North, since he stayed for seven years. He covered center field, with Goslin and Fox on either side of him in the championship seasons of 1934 and 1935, his only two years as a regular. In 1934, he stole 28 bases to help along his total of 97 invaluable runs scored to help bring home the flag. His strong throwing arm kept him in the majors until 1944.

BILLY ROGELL
CAREER 1925–1940 DETROIT 1930–1939

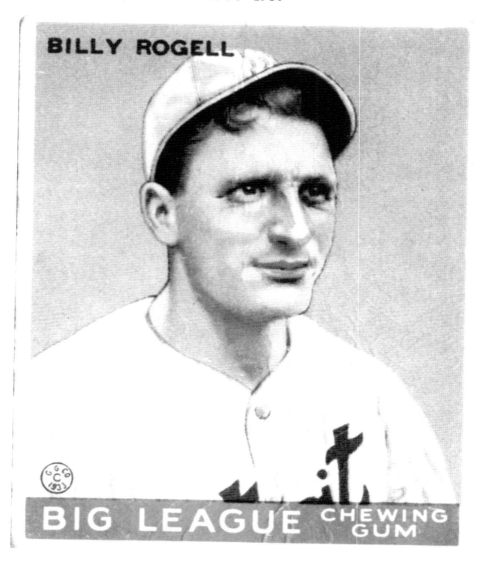

BILLY ROGELL

BIG LEAGUE CHEWING GUM

When we picked up Rogell from the Red Sox in the winter of 1928, we fans were all excited in Detroit. As a kid in the Boston organization, he had shown flashes of brilliance as a shortstop, and we thought we could develop that talent into stardom. We were right. A ball club is only as good as its players up the middle, and Billy solidified our shortstop position for a decade. He was our rock-solid defensive wizard up the middle, but at the same time was providing offensive pop throughout the 1930s. He was a switch-hitter who had some key hits in World Series contests, including four RBIs in game four of the 1934 World Series.

THE 1930S

TITLES IN TIGERTOWN

What was it about Mickey Cochrane that made such a big difference for the Tigers? The only major change made with our hitters in 1934 was the addition of Goose Goslin to our outfield trio. Alvin Crowder also showed up to help out the starting rotation, but other than that our team was essentially the same as in 1933, except for one more thing—Cochrane was hired as a *player*-manager. The big difference was that back in the 1933 season, we finished fifth in the league, 25 full games back of the Washington Senators. Only one year later in 1934, with Cochrane at the helm, we took the pennant with 101 victories, 26 wins better than 1933. We were quite sure that Mickey deserved a lot of credit, but we still are not sure how he did it. One popular opinion is that when Cochrane replaced Ray Hayworth behind the plate, he transformed the pitching staff into a winner, while strengthening the spine of the ball club up the middle.

Cochrane had been playing from 1925 to 1933 in Philadelphia under the tutelage of Cornelius McGillicuddy, a.k.a. Connie Mack. Cochrane was instrumental in the three straight American League titles won in Philly from 1929 to 1931. He was a great receiver, a top-notch game caller, and a catcher who could use a war club. If his lifetime .320 average, among the best all time for backstops, was not enough to prove his worth, please note he was always among the tops in fielding, winning a Gold Glove in both 1931 and 1933. The additional duties in Detroit kept Cochrane off the field more than he had been with the A's, but the time he put in with his starters, his relief pitching crew, with the infield and the outfield, and in constructing a strategy using speed and power throughout the 1934 season, brought success to virtually all of our players individually and synergistically to the team as a unit. His approach was welcomed and appreciated by the players, who had always suspected the talent on the club was worthy of at least a high finish in the league.

We went to the World Series that October of 1934, the first we had seen in Detroit in 25 years. We faced the Gas House Gang Cardinals that year and fought them a good fight until the seventh game. We split the first two games in Detroit, with Hank Greenberg blasting a home run in game one, which we lost, and Schoolboy Rowe winning a pitcher's duel for us in game two. At Sportsman's Park in St. Louis we played even better, taking two of the three games in Missouri, returning home with a 3–2 lead and a good deal of optimism. We thought Schoolboy could take them again, but Dizzy Dean's brother Daffy was on that day, throwing a seven-hitter against us in a 4–3 squeaker. And in game seven, still at home, we were blown out by brother Dizzy, losing decisively, 11–0. Immediately after that game, we looked forward to next year.

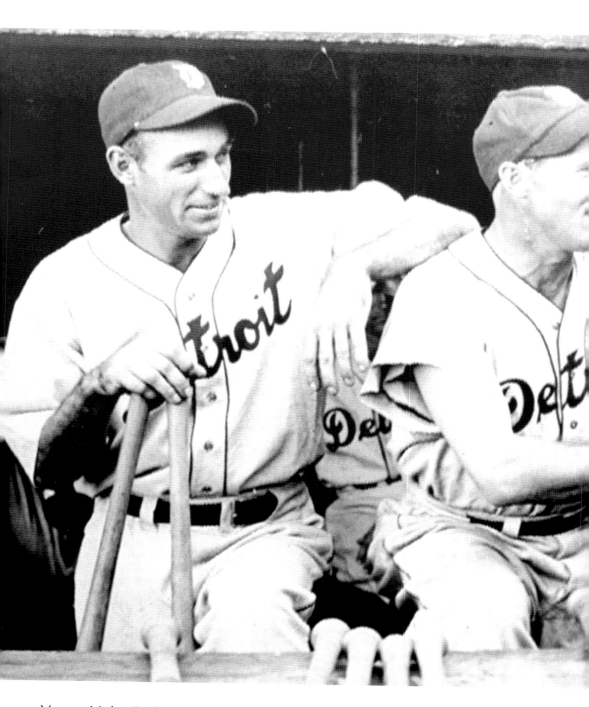

Manager Mickey Cochrane, far right, greets Goose Goslin, who arrived in Detroit simultaneously with him. Goslin, who had been a Washington Senator and a St. Louis Brown before coming to Detroit, would hit .305 and drive in 100 runs for the Tigers in 1934. The posed meeting in the dugout features three Tiger outfielders getting ready for the 1934 campaign. Pete Fox holds two

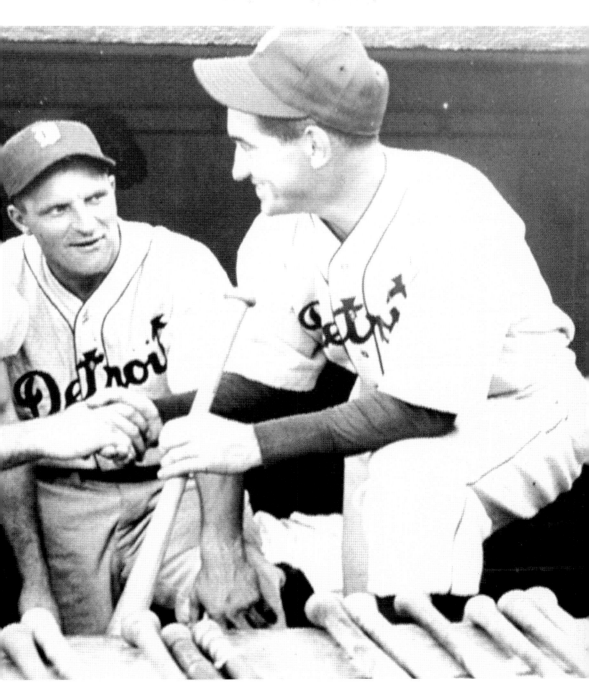

bats on the far left, and Frank Doljack, who was our utility man in the outfield, is seen between Goslin and Cochrane, third from the left. Our outfield was a major part of the team offense as we battled the Yankees all the way into September, a battle which we won, besting the New Yorkers by seven games.

Hank Greenberg
Career 1930–1947 Detroit 1930–1946

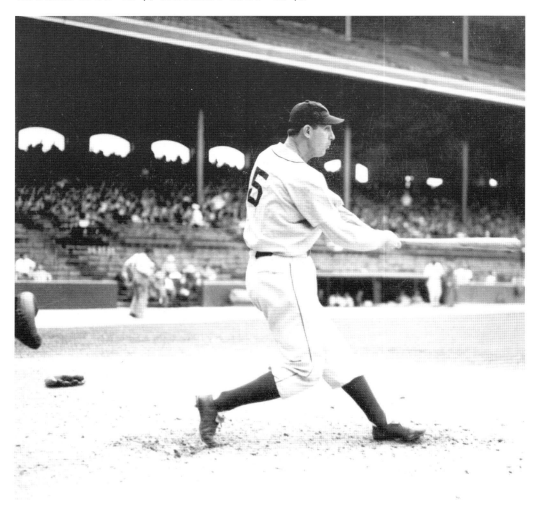

Big Hank Greenberg was an awesome force in our lineup and was the number one hero for our Jewish friends in Detroit. He became a symbol of courage for his people, the pride of the Tigers batting order, and later became the victim of prejudice that changed baseball history. But let's start by describing Greenberg's hitting feats through the 17 seasons he wore a Tigers uniform. Hank was a huge man who grew up in the Bronx but was not able to turn his potential into a baseball contract in New York. He achieved success via hard work rather than raw talent, overcoming a native clumsiness in order to develop into a reasonably good first baseman and outfielder.

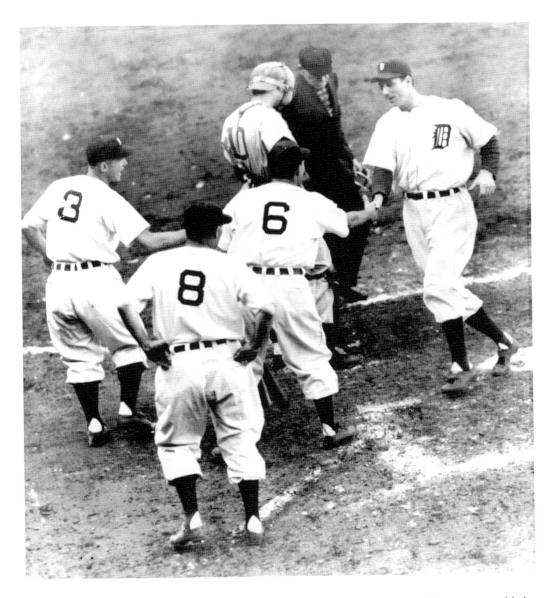

By 1934, Greenberg's power was becoming evident, leading the league in doubles with 63, while driving in a whopping 139 runs, on top of a .339 batting average. By that time, the Giants and Yankees were both sorry they let Hank get away to the Midwest. The following year, which we played as American League champions, saw only improvement in Greenberg's numbers, with his most notable achievement being his staggering 170 runs batted in. Most major leaguers would be happy with but 70 RBIs, but Hank bashed in 100 more! His .328 batting average and 36 home runs did not escape notice, as the Greenberg bat led the Tigers into the 1935 World Series versus the Cubs. His hitting feats brought him the MVP award for 1935, but a broken wrist in game two of the World Series sat Greenberg on the bench, as his teammates brought victory home to Detroit.

Hank Greenberg reinjured his wrist at the start of the 1936 season, and he did not see action again until spring training in 1937. Greenberg once again established himself as a slugging machine for the Tigers, hitting 40 home runs and this time driving in an astounding 183. The success he saw in 1937 and what he had learned about American League pitching set Greenberg onto a quest during the season of 1938. In the photograph above, Greenberg has some pre-game fun with the fans, picking up the fruit and candy his female admirers had been throwing at him.

Determined to tie or break Babe Ruth's 60 home run mark, Hank had compiled 58 round trippers with five games left in the 1938 season, already tying the record for right-handed hitters, held previously by Jimmy Foxx alone. But racism reared its head. Although it was never spoken of out loud, it was clear to all in the baseball community that a conspiracy of sorts had been organized amongst league pitchers to prevent a Jew from becoming baseball's home run king. Greenberg hardly saw a strike in those last few games, and he had to be as disheartened by the treatment as we Tiger fans were rooting hard for Hank. It was not that 58 home runs was not a measure of pride for us, but coming so close to the mighty Babe proved frustrating. The photograph above shows Del Baker discussing the choice of restaurants in Chicago with Greenberg.

GOOSE GOSLIN
CAREER 1921–1938 DETROIT 1934–1937

Leon Allen "Goose" Goslin spent less time in a Tiger uniform than with the Washington Senators, but as with every other stop, he had an impact. Goose was a natural hitter, starting in Washington with a .324 rookie batting average in 1922. Coming to Detroit after the 1933 season, he was just what the Tigers needed to get past the Yankees. In Goslin's first two years in Detroit, in 1934 and 1935, he batted .305 and .292, respectively. More importantly, in 1934, he had a runs and runs batted in combination statistic of 206; that's 106 runs and 100 RBIs.

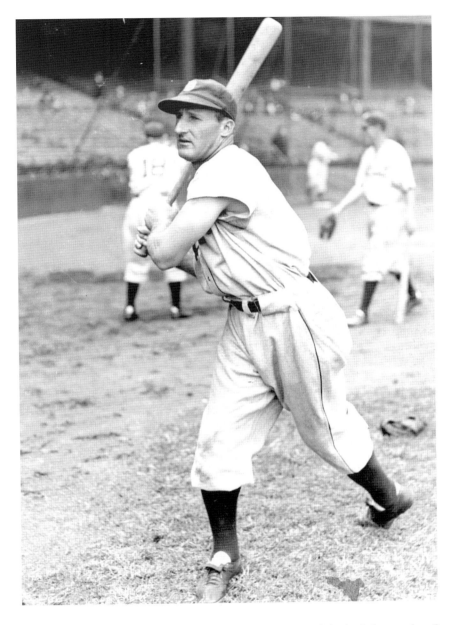

Goslin must have liked Mickey Cochrane, since he felt at home at Briggs stadium right away and performed well for the new skipper. The year 1935 saw him knock in 109, to go with his 34 doubles and .415 slugging percentage. The Goose ended up with a .316 lifetime batting average, to go with a total of 2,735 hits over his 18-year season. His other major-league club had been the St. Louis Browns, offering Goslin no opportunities for post-season play, and really not much hope at all for being with a winner. The Browns were always bottom feeders, but that did not stop Goslin's batting prowess from shining through. For those lousy Brownies teams he drove in 100 or more runs every single season.

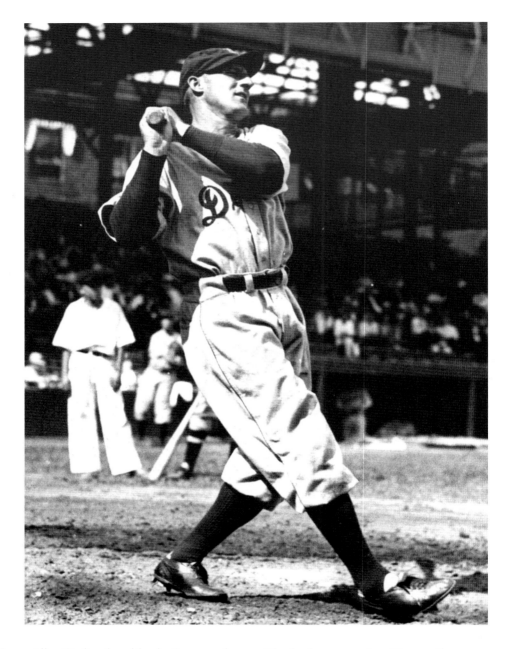

Leon Allen Goslin played for the Senators three different times, including the pennant-winning season of 1933, just before he came to Detroit. Although he was never admired for his glove work in the outfield, he was a winner, playing in three World Series in Washington, and for two post-season World Series with us in Detroit.

The final two years in a Tiger uniform were not quite so successful, and by 1937, his career was about done. Goslin was down to 181 at-bats in 1937, and closed out his career with one more appearance for the Senators in 1938.

Mickey Cochrane combined superb playing skills, unusual leadership abilities, and a remarkable on-field intensity that helped bring championships to Philadelphia when he played with the Athletics, and with us in Detroit. He hated to lose and worked ferociously to prevent it, whether playing behind the plate, or running the whole show from the dugout. He was trusted by his hurlers to call a strategic game, and he used his bat as an offensive weapon in the clutch, hitting a amazing .346 during the three World Series years with the A's. His .320 lifetime batting average beats all other catchers in major-league history, and his on-base percentage of .459 in 1933 led the American League.

Mickey Cochrane's fiery nature and demanding presence on the field compelled his charges to play with concentration, intelligence, and cooperation, which was just what we needed to transform an obviously talented team into a winner. By 1936, he would spend most of his time wearing the manager's hat, having handed the starting catcher's job back to Ray Hayworth. The years with us in Detroit were his only ones as manager, lasting from 1934 to 1938. Strangely, he never ran another ball club after the Tigers' stunning successes. But that fact allows us to claim Cochrane as our own hero and champion.

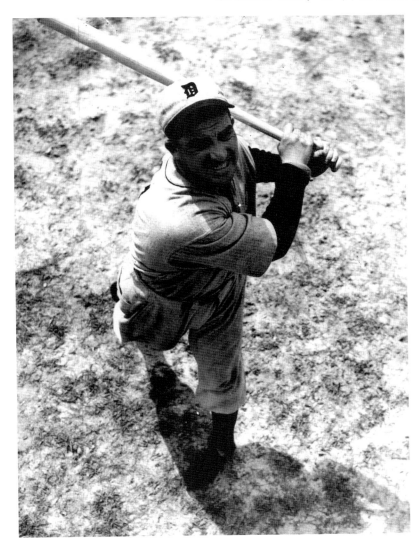

One more future Hall of Famer was to enter our midst in 1936, namely fun-loving Al Simmons. Right after our World Series triumph in 1935, we acquired Simmons from the White Sox and signed him to a one-year contract. He knocked in 112 runs for us that year, batting .327, while winning a Gold Glove in center field with a .986 fielding percentage. Naturally, we all wanted Simmons to stay. But maybe the bosses did know what they were doing, as it turned out to be Simmons's last full season in the major leagues. Simmons always regretted not achieving the 3,000-hit plateau, missing that mark by 73. He played on until 1944, long past his prime, but those dwindling years did little harm to his .334 lifetime batting average.

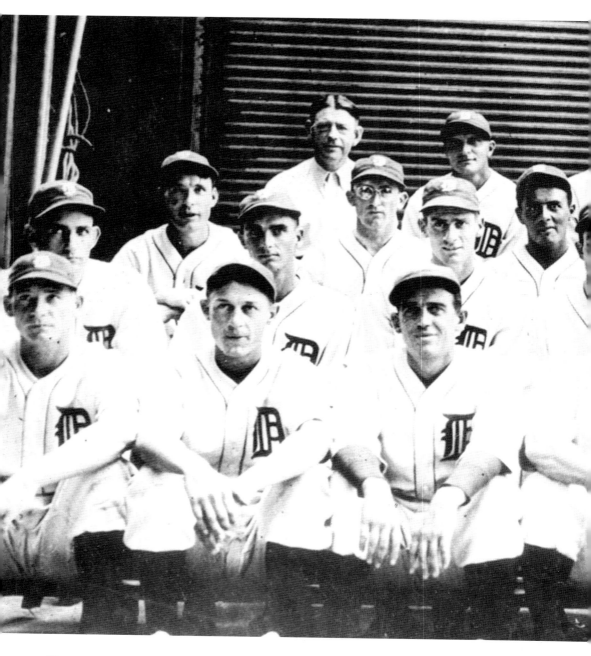

We Tiger fans are always glad to look back on that World Champion team of 1935. But every time we see this team portrait from that season, we wonder why this peculiar spot was used as a backdrop for photographs so often. The team photographer had a special affinity for this garage door, somewhere in the bowels of Briggs Stadium. Front row to back, checking out the personnel, Charlie Gehringer sits second row, far left; Goose Goslin front row, far right; Hank Greenberg second row, far right; Del Baker, front row, third from right; and Mickey Cochrane front row,

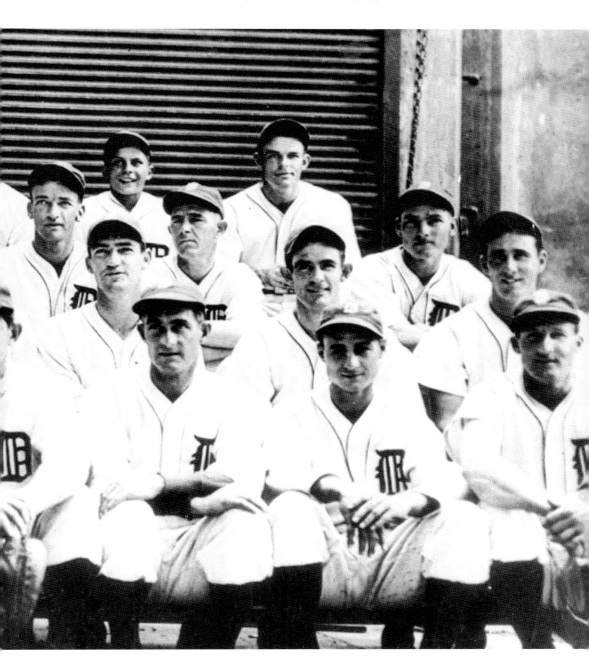

middle. This outfit was the result of years of quality acquisitions by the Tigers, through the Bucky Harris years, culminating in the arrival of Mickey Cochrane, who had that magic touch, activating the diverse talents of his players into a unit, a team with common purpose and goals. But like most culminations, we knew a downward slide was coming. We were proud of our boys, and we know the players were proud of what they had accomplished in that unforgettable year of 1935.

Do these guys look stricken with pennant fever? This photograph provides a better look at the slugging foursome that helped bring home the pennants in 1934 and 1935. In those two seasons, this quartet combined for some astounding numbers. In 1934 alone they scored 442 runs, 442 runs batted in, 52 home runs, and smacked a staggering 183 doubles. The year 1935 saw a slight drop in those numbers in every category but home runs, even in the RBI column, where Hank Greenberg recorded 170 all by himself. In the photograph above, Mickey Cochrane

is at left, Charlie Gehringer, next to him, who appears to have just gotten an elbow in the ribs from Goose Goslin, third from left, with Hank Greenberg, far right. The picture makes evident just how huge Greenberg was. He and Schoolboy Rowe, his equal in height, would tower over almost all other players in the league. The photograph was taken as fans were filing into the ballpark in August 1935.

Barney McCoskey
Career 1939–1953 Detroit 1939–1946

If Barney McCoskey could have maintained the pace he set in his first two seasons in Detroit as a rookie and a sophomore, he would now be in the Baseball Hall of Fame. After getting to the majors, six of his first seven seasons saw him hitting in the .300s. He quickly became the American League's premier leadoff man, topping the league in hits with 200 in 1940. In that pennant-winning season, McCoskey was instrumental, scoring 123 runs for manager Del Baker. His World War II service years were hard on McCoskey, whose career never returned to form after his return in 1946. Shortly thereafter, the Tigers traded Barney to the Athletics for George Kell.

Roy Cullenbine seemed to be most successful with his bat when he would not use it. He drew bases on balls at a rate that much improved his on-base percentage. Some complained he was too timid at the plate, but the walks he piled up every year helped keep him in the majors. He sandwiched his major-league career around two stints in Detroit, playing here as a rookie, and then seven years later on the verge of retirement. You really could never call Cullenbine a slugger, but he was on base a lot for our many sluggers to drive in.

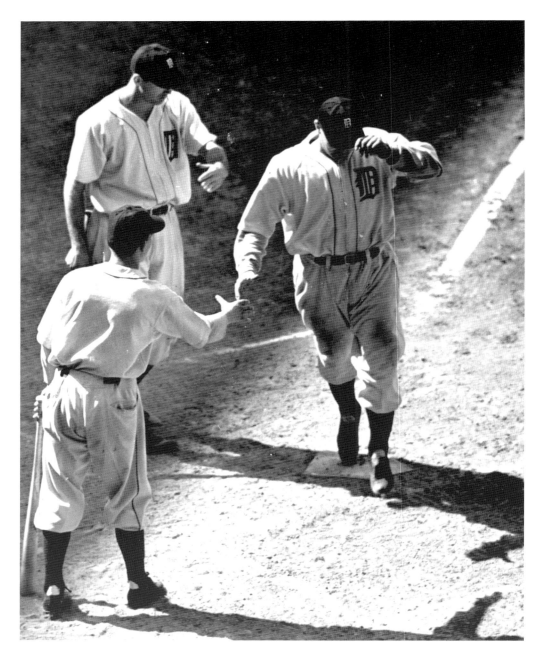

Here was a familiar sight at Briggs Stadium during the 1930s. That is Billy Rogell tipping his cap after hitting another of his many home runs, greeted at home by Hank Greenberg, on the upper right. Our lucky batboy is stretching out his hand for a shake. If you love the long ball, you would have loved this Tiger team. Outside of our pitchers, anyone in our lineup was a home run threat, and we loved those front row, outfield bleacher seats, where we would catch one over the fence every year or two.

Earl Averill was brought to Detroit late in his career as a secure backup for our outfielding corps. Always a fine fielder, Averill could also handle a bat, even in his advanced years. We might not have won the pennant in 1940 without Averill's help that summer. He batted .280 and knocked in an important 20 runs for us. His year and a half in Detroit did not do much to get Averill into Cooperstown's Hall of Fame, but his 11 straight powerful years in Cleveland certainly did. After one more season in 1941, with the Boston Braves of the National League, Averill retired.

DEL BAKER

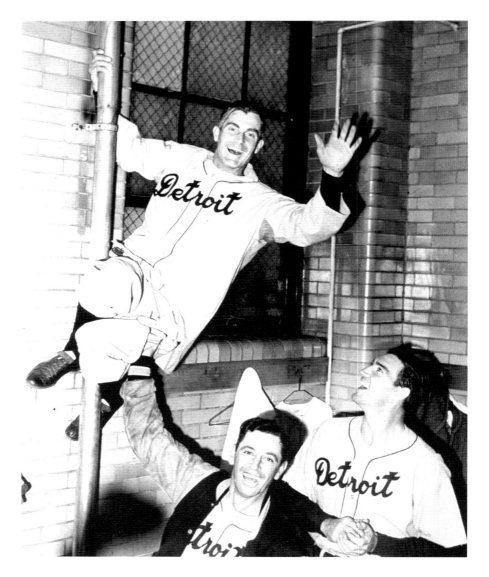

Jubilant Del Baker was so excited about winning the pennant in 1940 that he was climbing poles and shouting out loud. Baker had not been much of a player. A catcher by trade, Baker spent only three years in the big leagues, all with Detroit, where he compiled a discouraging .209 average. But every minute he was sitting the bench or warming up relief pitchers in the bullpen, Baker was soaking up observations, analyses, and strategies he would use in later years. Baker had been manager for the Tigers for a portion of a season, in between the regimes of Bucky Harris and Mickey Cochrane. When he was hired outright in 1938, he began to put all that knowledge and wisdom to work.

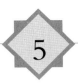

WORLD WAR II
AND BEYOND

After flying the American League flag following the 1940 season, Del Baker stayed on as manager for another two years. We tied for fourth in 1941, finishing four games under .500, and then fifth in 1942, winning but 73 games. But our attention was not so much on baseball back then. The war in Europe had widened, and as the United States became part of it, even the wildest baseball fan lost a little interest in what went on in the major leagues. Simultaneous to fans losing interest was the decline of the talent pool as the war took its toll. With so many able-bodied young men entering the military, professional ball could not find the caliber players available before. Winning the pennant would not have meant very much in those years of 1942, 1943, and 1944, but by 1945, peace had returned, and things were looking up worldwide.

While the war raged in 1943, Steve O'Neill came to Detroit as our manager. O'Neill had only played in Detroit as an opponent, catching for the Cleveland Indians from 1911 to 1923. He had three brothers in professional ball, having developed on the diamonds of the Pennsylvania coalfields. He retired from the playing field in 1928 and began a new career in the dugout, first managing in the majors with, not surprisingly, Cleveland in 1935. His charges never came in higher than fourth in the American League, but the Tigers saw something in him, both before offering him a contract, and after finishes in Detroit of fifth and second in 1943 and 1942. With the darkness of the war years lifted, baseball brought bigger headlines, and managerial work would mean a lot more, at least in the public eye. O'Neill handled pitchers well when behind the plate in Cleveland, and he could do the same as a skipper. Realizing that the Tigers were not fully utilizing the talents of the American League's top left-hander, Hal Newhouser, O'Neill refocused Newhouser's concentration, and we won the pennant in 1945.

We earned the right to play the Cubs in the World Series in 1945, with only 88 wins under our belts. Chicago fielded a team with no big stars, just a conglomeration of grizzled veterans; meanwhile, we had Hank Greenberg and Hal Newhouser, who would have been stars in any era. We took advantage of our talent in the World Series and battled hard in each tension-filled game, finally pulling it out in seven. We had to meet in Wrigley Field for that seventh game, and we sent out Newhouser to pitch against the Cubs's Hank Borowy. Borowy had appeared in the previous two games, and he looked tired instead of tuned in, and he got an early hook. But we kept pounding the ball against Cubs pitchers, Paul Derringer in the first, Harry Vandenberg in the second, Paul Erickson in the sixth, Claude Passeau in the eighth, and Hank Wyse in the ninth. With Newhouser throwing a complete game, the 9–3 victory and World Championship were easily in hand that day.

RUDY YORK
CAREER 1934–1948 DETROIT 1934–1945

Rudy York was a Tiger through and through. Ten of his 13 major-league seasons were in Detroit, and he was productive in all of them. Trained for the role of slugging first baseman in the minors, big Rudy had to switch to catcher or third base in order to get into the Tiger lineup, with Hank Greenberg holding down first. In his rookie year of 1937, he set major-league records for the month of August for both home runs (18) and runs batted in (49). His sparkling rookie statistics included 35 home runs, 103 RBIs, and a batting average of .307. He completed a long career with a .275 batting average and a total of 277 round trippers.

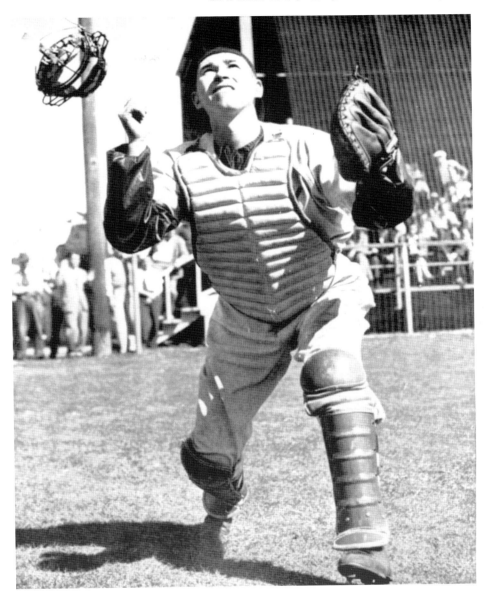

Hal Wagner had a 12-year big-league career as a catcher, mostly serving as a backup and bullpen receiver. He appeared in box scores for the Athletics and Red Sox more than for the other teams he served. Wagner spent most of two seasons in Detroit, coming over from Boston in 1947, and leaving for a job with the Philadelphia Phillies at the end of 1948. In between, he played 125 games, batting .288 for the Tigers in 1947. But his .202 average the following year did not cut it, and he was traded.

Eddie Mayo
Career 1936–1948 Detroit 1944–1948

Five of Eddie Mayo's nine major-league seasons were in Detroit. He came to the Tigers in 1944 as a third baseman, but was successfully converted to second, where he thrived. By the next season, he was best of all second sackers in fielding, with a percentage of .980. Mayo, who may have benefited from the personnel crunch during World War II, was never much of a hitter. But during the Tigers pennant campaign in 1945, Mayo socked 10 home runs and drove in 54 for the cause. Eddie stayed in Detroit, playing full seasons until his retirement in 1948.

"Birdie" Tebbetts wore the tools of ignorance for three teams over 14 major-league seasons. He received his nickname because of his high-pitched voice. His 10 years in Detroit made him a Tiger for all time in our eyes. He became our number one catcher in 1939 and continued in that role until Paul Richards arrived in 1943. Proving once again that receivers make the best managers, Birdie went into the dugout to manage for 11 campaigns with Cincinnati, Milwaukee, and Cleveland. A major disappointment for Tebbetts was missing a World Series trip with the Tigers in 1945, since his military service had not been completed. He worked behind the plate his entire career, racking up a total of 1,162 games played.

Bruce Campbell
Career 1930–1942 Detroit 1940–1941

Bruce Campbell is one of those journeyman players from the 1930s that most fans have never heard of. But Campbell was a solid major-league outfielder for 13 seasons, all in the American League. Plagued by chronic injuries, Campbell battled spinal meningitis, cerebral spinal fever, and more to maintain a regular playing schedule while with five different teams. While playing in Philadelphia, he was honored as "most courageous athlete" by local writers. In the 1940 World Series, Bruce played in all seven games and hit .360, with a home run and five runs batted in.

Eddie Lake
Career 1939–1950 Detroit 1946–1950

Middle infielder Eddie Lake's bat was never feared by American League pitchers, but his batting eye was. Lake was famous for drawing walks, picking up a base on balls in every five times at bat. In three years, he totaled more than 100 walks, but never hit higher than .279.

Meanwhile, his clever glove kept the paychecks coming, with 1946 and 1947 seeing Lake play full seasons at shortstop for the Tigers. The appearance of Johnny Lipon cut Lake's playing time in 1948.

Dick Wakefield
Career 1941–1952 Detroit 1941–1949

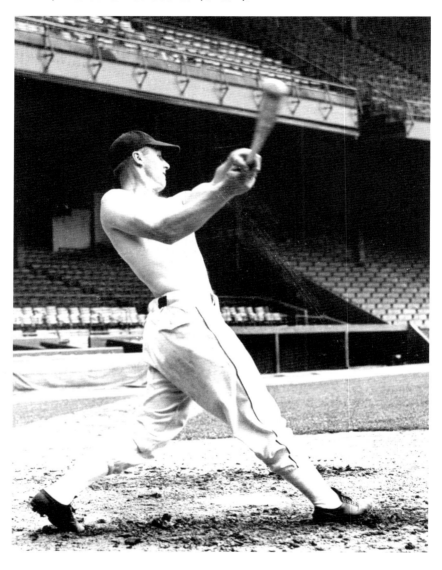

It must have been hot on the day when the above batting practice photograph was taken. A shirtless Dick Wakefield used continuous work in the batting cage to compile a .293 lifetime batting average. In his second season in Detroit, in 1943, still officially a rookie, Wakefield bested all other American Leaguers with 200 hits. His quick start made the $52,000 the Tigers paid him as a signing bonus look like a bargain. That same year, he was second in American League hitting with a .316 average and crashed a league-leading 38 doubles. In 1944, he raised his average to .355, but from there the numbers went downhill. He missed the 1945 season and, as a result, his only chance to play in a World Series.

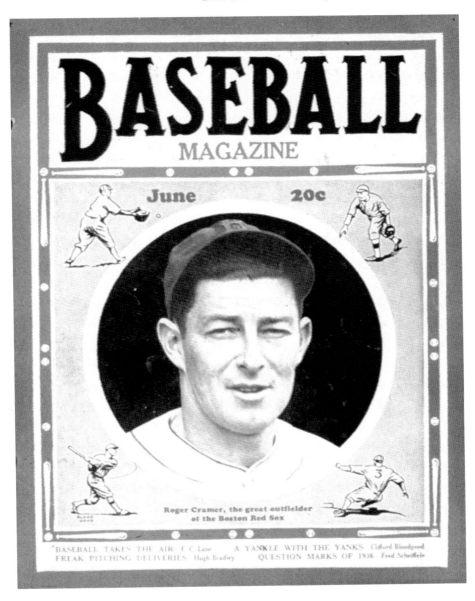

Roger Cramer, the great outfielder
of the Boston Red Sox

"BASEBALL TAKES THE AIR- F. C. Lane A YANKEE WITH THE YANKS Clifford Bloodgood
FREAK PITCHING DELIVERIES Hugh Bradley QUESTION MARKS OF 1936 Fred Scheiffele

Roger "Doc" Cramer was a wily veteran when he came to the Tigers in 1942. A talented center fielder who usually batted lead off, he was known to all as a reliable singles hitter. He twice had six hits in a game and is the only player ever to accomplish that feat. He played for us in the 1945 World Series, hitting .379 in all seven games, knocking in four runs. Even at age 40, Cramer was fast enough to play center and strong enough to rattle the ball around the park for a high average.

Jerry Priddy
Career 1941–1953 Detroit 1950–1953

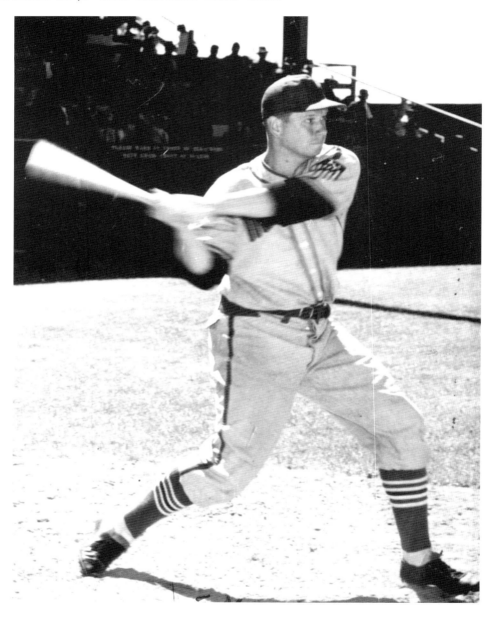

Jerry Priddy had a frustrating time in the majors before coming to the Tigers. He could not beat out Joe Gordon for the Yankees' second base job, and as a result, he ended up in Washington for three seasons. He was a solid fielder, who would usually top the .250 mark each year. He played second base exclusively for Detroit, in a starting role in 1951 and 1952, and then backing up Johnny Pesky in 1953.

WORLD WAR II AND BEYOND

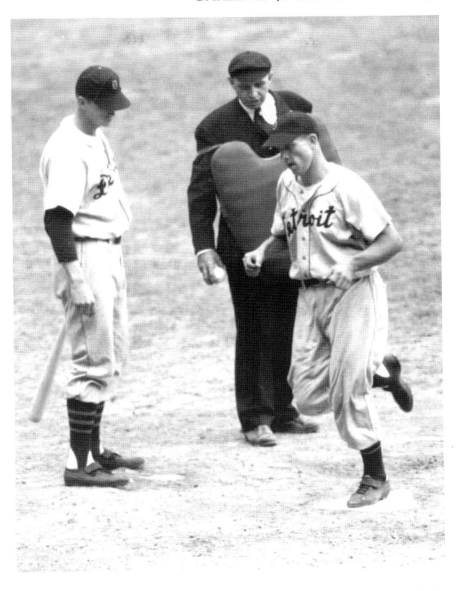

Walter Evers was expected to become a big star. After battling through World War II military tours and injuries in 1946, Evers played his first full year in center field for the Tigers in 1947. He came up a little short of .300 in 1947, but in 1948, he batted .314; in 1949, he batted .303; and in 1950, hit .323, while leading the American League in triples with 11. That 1950 season was Evers's best, playing in the All-Star game and finishing up with 21 home runs with 103 runs batted in. At the very beginning of 1952, he was traded to the Red Sox.

Vic Wertz
Career 1947–1963 Detroit 1947–1952, 1961–1963

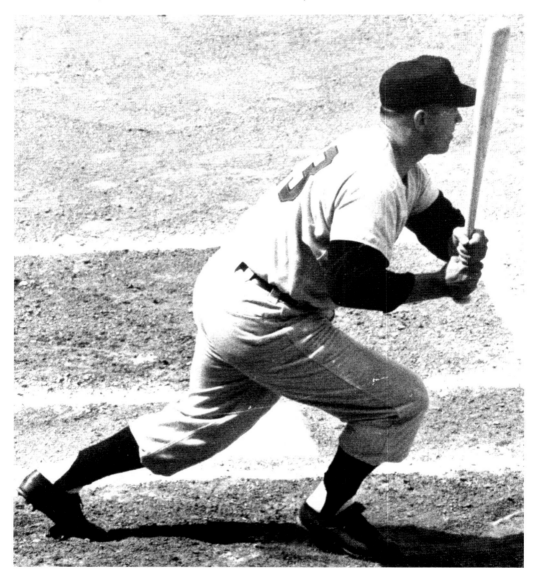

Vic Wertz was a left-handed power hitter who in 1947 moved into our starting lineup immediately, batting .288 as a rookie. Often a streaky batter, his hottest period may have been when he hit seven homers in five straight games. We always thought it was a mistake to get rid of Wertz. He had some fabulous seasons for us, including 20 home runs, 133 runs batted in, with a .304 average in 1949; 27 home runs, 123 runs batted in, with a .308 average in 1950; and 27 home runs, 94 runs batted in, and a .285 average in 1951. Apparently not good enough for the Tiger brass, Wertz was off to St. Louis the following year.

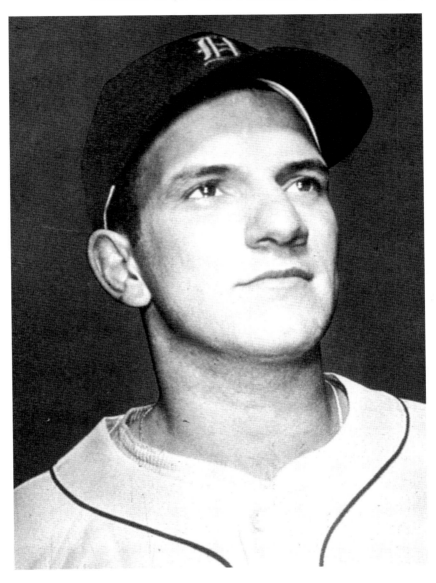

The year 1950 was Johnny Groth's best, and we enjoyed watching it in Detroit. After being touted as a phenom on magazine covers across the country, Groth was in his fifth year with the Tigers when he finally connected for 12 home runs, 85 RBIs, and an average of .306. He was our starting center fielder for four seasons, from 1949 to 1952. After that, he bounced around the majors until the middle of 1957, when he came back to the Tigers in a trade with the Kansas City Athletics. He played decent ball for us as an older player, both as a starter and as a substitute.

George Kell
Career 1943–1957 Detroit 1947–1952

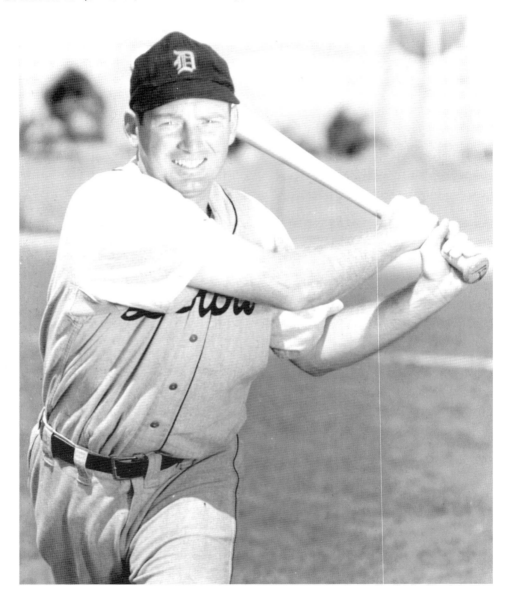

To many, George Kell is an odd choice for the Baseball Hall of Fame, but we in Detroit who saw him work for five full seasons and parts of two others know full well what a quality player he was. An All-Star third baseman elected four times, he maintained a .300 average throughout his 15-year career, ending with a .306 mark. He batted .300 or better for eight consecutive years, winning his only batting title in the midst of the streak, hitting .343 in 1949.

WORLD WAR II AND BEYOND

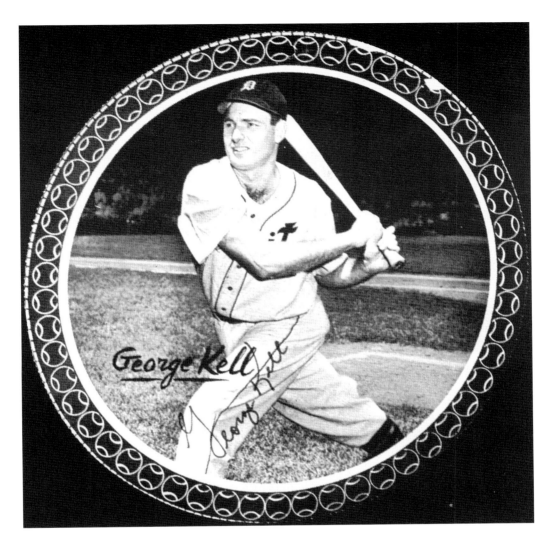

It was an exciting race for the batting championship in 1949, with the contest coming down to the last ball game. Ted Williams did not get a hit, but George Kell had a better day and won the title by .0001. He was better in 1950, but his .340 average could not win the title, but he did lead the league in hits with 218, to go with 56 total doubles. But Kell was celebrated mostly as glove man at third, where he set the standard in the American League. He won numerous Gold Glove awards, leading all rivals in fielding percentage in 1945, 1946, 1950, 1951, 1953, 1955, and 1956. After retirement in late 1957, Kell returned to his favorite team and city to become our radio play-by-play man. Kell became a Hall of Famer in 1983.

Walt Dropo
Career 1949–1961 Detroit 1952–1954

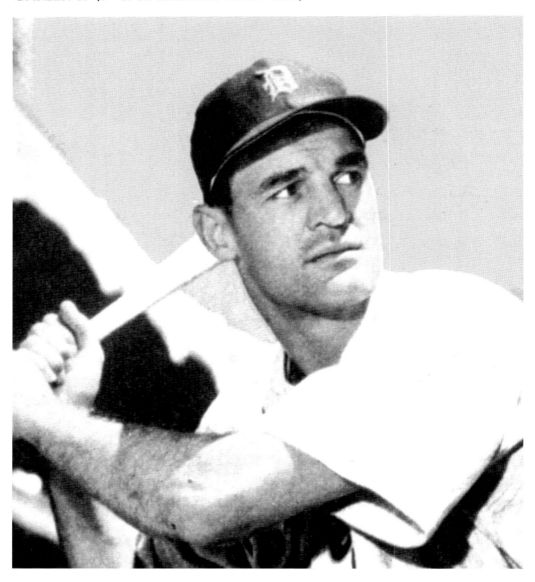

Walt Dropo came to Detroit in a blockbuster trade with the Red Sox, which also saw George Kell leave for New England. "Moose" was a gigantic six-feet-five-inches tall and weighed 220 pounds, using every bit of his powerful frame to play first base in the majors for 13 years. He won rookie of the year for Boston in 1950, after turning down a National Football League contract to sign with them. He knocked in an astonishing 144 runs that campaign for the Red Sox, to go with his 34 four baggers. His first seven seasons were his best, playing full time at first base.

Tuttle was known mostly as a fleet-footed center fielder, playing in Detroit's starting lineup for seven straight seasons, after coming up as a rookie in the spring of 1952. He would bat around .250 most years, occasionally for power. He was a star at Bradley University, where the Tigers found him and signed him with great hopes. He did pay off defensively, besting all other outfielders in assists and putouts in a number of years. Over time, Tuttle had contracted facial bone cancer from the use of smokeless tobacco, and in recent years, he has campaigned against its use by young professional players.

How could we ever forget this trio? These boppers used their bats to keep all of Detroit entertained during all of 1959, with Rocky Bridges, center, playing only a year and a half in a Tiger uniform. But Harvey Kuenn (left) and Al Kaline (right) were teammates from 1952 to 1959, hitting all the way. The "K" boys put a lot of pressure on American League pitchers, with Kuenn hitting for average, and Kaline hitting everything for power and average. Bridges was famous for his

unusual batting stance, termed the "rocking chair" style. The style of the two "K's" was less distinctive, but oh so more effective. Kuenn was the American League rookie of the year and elected to the All-Star game every year from 1953 to 1960. Kaline joined Harvey on All-Star teams from 1955 to 1960, and then continued to be elected annually until 1967. They were our offensive combination that all American League hurlers wanted to avoid.

DETROIT SLUGGERS

AL KALINE
CAREER 1953–1974 ALL IN DETROIT

Al Kaline was the most popular Tiger for more than a decade, a classy performer both in the field and at the plate. Al was our right fielder for his entire major-league stay, covering over 20 years as "Mr. Tiger." Smooth, graceful, fast, and talented, Kaline built up his wrist strength in his early years in the bigs, to turn into a solid extra base hitter. He grew up in Baltimore, discovered on the sandlots there by Tiger scout Ed Katalinas, and saw no minor-league action before arriving in Detroit. He vaulted into baseball stardom after his remarkable 1955 campaign, when he led the league in hits with 200 and led the league in hitting at .340, as he clobbered 27 homers with 102 teammates driven in.

Kaline's annual statistics went up and down to a moderate extent, but consistency was one of his career hallmarks. What did the most damage to his numbers were the nagging injuries that cropped up at various points during his playing days. For example, Kaline's 1962 season was off to a flying start when he fractured his collarbone. Projecting his numbers for a complete season, Kaline might have knocked 40 home runs that year, when he had to settle for 17. These types of niggling injuries kept Kaline from the magic plateau of 400 lifetime home runs coupled with 3,000 hits.

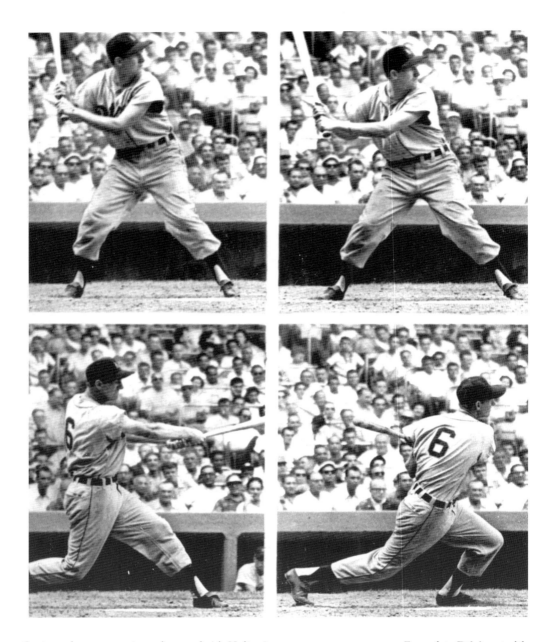

Seeing the stop-action shots of Al Kaline's picture-perfect swing, one is reminded of a baseball instructional manual. If a manager could acquire a whole team with the work ethic and skills of a Kaline, he would win pennants every year. From his DiMaggio-like batting stance, to his concentration on the ball, to his smooth follow-through and speedy departure from the batters box, Kaline was a model of efficiency and productivity.

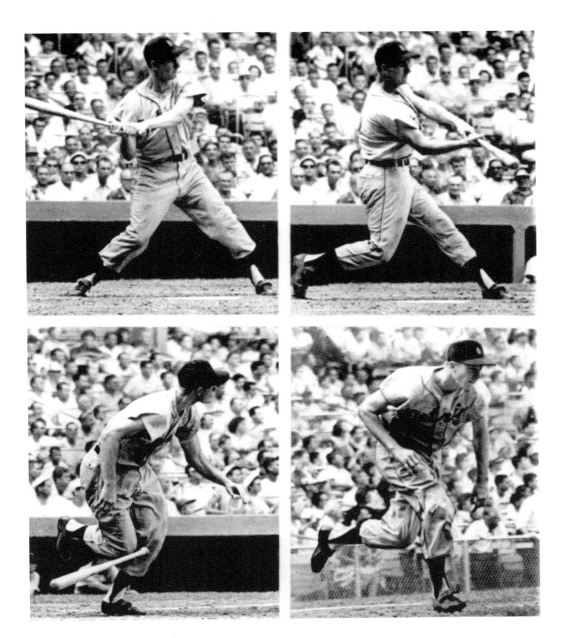

Kaline was appreciated and almost worshipped in Detroit for his entire career, in an era where big stars could stay with one team from rookie season to retirement. And that kind of loyalty in Kaline made him a household word for two decades. His 3,007 lifetime hits left him with a .297 average. He came up two doubles short of 500; he was one home run shy of 400, while scoring 1,622 total runs. We want him back!

BUBBA PHILLIPS
CAREER 1955–1964 DETROIT 1955, 1963–1964

Maybe you remember John Melvin Phillips playing third base in a White Sox uniform in the 1959 World Series. Bubba was there, but he started and finished his career in Detroit. The stocky infielder played his only full season for the Tigers in 1963, when he drove in 45 runs, while scoring 42. A .255 career hitter, Phillips was good enough to stay in the starting line up for three teams in six of his ten major-league years, combining a talented glove with a reliable bat.

Utility infielder Reno Bertoia played second base, third, and shortstop for four different American League teams, including two separate stops in Detroit. Hired for his glove primarily, his best year with a bat was 1957, when he hit .275 for the Tigers. In his most complete season, he appeared in 121 games for the Washington Senators and batted .265. His return to the Tigers in 1961 was as a late inning backup infielder, and after 29 games in MoTown, he retired.

CHARLIE MAXWELL
CAREER 1950–1964 DETROIT 1955–1962

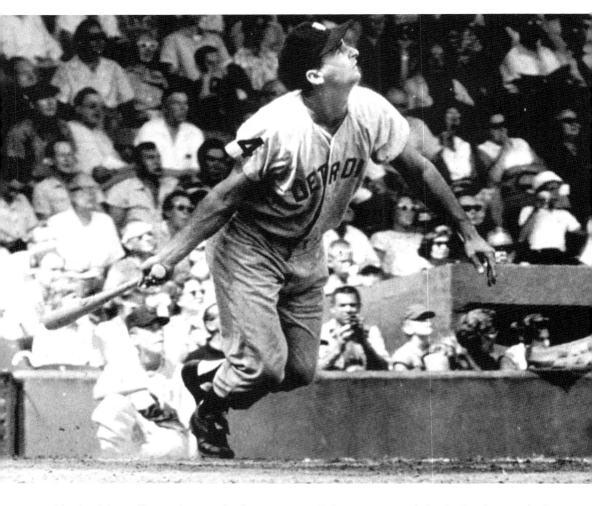

Charlie Maxwell was famous for hitting on Sundays. Although the baseball encyclopedias do not break those statistics down, Maxwell's reputation was well earned. He became an outfield starter in his second season, when he bashed 28 home runs, and made the All-Star team. In four seasons, Charlie hit more than 20 home runs, with his high of 31 reached in 1959. One of the most popular left-handed sluggers we ever had, Maxwell's gift to us was the long ball. He hit all told 148 round trippers, while knocking in 532. His strongest years were with us in Detroit.

Right away, Harvey Kuenn was expected to perform well, and he did. Winning the rookie of the year award in 1952, Kuenn led the league that year in hits, with 207, while batting .308 for the Tigers. A persistent singles hitter, he led the American League four times in total hits. He had a lifetime batting mark of .303, playing for five different clubs. After leaving the field of play, he became a manager for three years in Milwaukee.

BIBLIOGRAPHY

The Baseball Encyclopedia. New York: Macmillan, 1976.

Cohen, Richard M., David S. Neft, Roland T. Johnson, and Jordan A. Deutsch. *The World Series* New York: Dial Press, 1976.

Lieb, Frederick. *The Detroit Tigers.* New York: Putnam, 1946.

Lowry, Philip J. *Green Cathedrals.* Cleveland: Society for American Baseball Research, 1986.

Okkonen, Marc. *Baseball Uniforms of the 20th Century.* New York: Sterling, 1991.

Reach Baseball Guides. Philadelphia: A. J. Reach and Company, 1882–1920.

Riley, James. *The Biographical Encyclopedia of the Negro Leagues.* New York:Carroll and Graf, 1994.

Shatzkin, Mike, ed. *The Ballplayers.* New York: Arbor House, 1990.

Spalding Baseball Guides. Springfield, MA: Spalding Publishing, 1882–1935.

Thorn, John, Peter Palmer, and Michael Gershman, eds. *Total Baseball.* Total Sports, 1999.

All photographs courtesy of Transcendental Graphics / theruckerarchive.com.